ALISON BECHDEL: CONVERSATIONS

Conversations with Comic Artists M. Thomas Inge, General Editor

Alison Bechdel: Conversations

Edited by Rachel R. Martin

University Press of Mississippi / Jackson

The University Press of Mississippi is the scholarly publishing agency of the Mississippi Institutions of Higher Learning: Alcorn State University, Delta State University, Jackson State University, Mississippi State University, Mississippi University for Women, Mississippi Valley State University, University of Mississippi, and University of Southern Mississippi.

www.upress.state.ms.us

The University Press of Mississippi is a member of the Association of University Presses.

Images courtesy of Alison Bechdel

First printing 2018
∞

Library of Congress Cataloging-in-Publication Data

Names: Bechdel, Alison, 1960– interviewee. | Martin, Rachel R., editor.
Title: Alison Bechdel : conversations / edited by Rachel R. Martin.
Description: Jackson : University Press of Mississippi, [2018] | Series:
 Conversations with comic artists | Includes bibliographical references and
 index. |
Identifiers: LCCN 2018028112 (print) | LCCN 2018032824 (ebook) | ISBN
 9781496819284 (epub single) | ISBN 9781496819291 (epub institutional) |
 ISBN 9781496819307 (pdf single) | ISBN 9781496819314 (pdf institutional)
 | ISBN 9781496819260 (hardcover : alk. paper) | ISBN 9781496819277 (pbk. :
 alk. paper)
Subjects: LCSH: Bechdel, Alison, 1960-—Interviews. | Cartoonists—United
 States—Interviews. | LCGFT: Interviews.
Classification: LCC PN6727.B3757 (ebook) | LCC PN6727.B3757 Z46 2018 (print)
 | DDC 741.5/973—dc23
LC record available at https://lccn.loc.gov/2018028112

British Library Cataloging-in-Publication Data available

Books by Alison Bechdel

Dykes to Watch Out For (1986) Firebrand Books
More Dykes to Watch Out For (1988) Firebrand Books
New, Improved! Dykes to Watch Out For (1990) Firebrand Books
Dykes to Watch Out For: The Sequel (1992) Firebrand Books
Spawn of Dykes to Watch Out For (1993) Firebrand Books
Unnatural Dykes to Watch Out For (1995) Firebrand Books
Hot, Throbbing Dykes to Watch Out For (1997) Firebrand Books
Split-Level Dykes to Watch Out For (1998) Firebrand Books
*The Indelible Alison Bechdel: Confessions, Comix, and Miscellaneous Dykes to Watch Out
 For* (1998) Firebrand Books
Post-Dykes to Watch Out For (2000) Firebrand Books
Dykes and Other Carbon-Based Life-Forms to Watch Out For (2003) Firebrand Books
Invasion of the Dykes to Watch Out For (2005) Firebrand Books
Fun Home: A Family Tragicomic (2006) Houghton Mifflin
The Essential Dykes to Watch Out For (2008) Houghton Mifflin
Are You My Mother? A Comic Drama (2012) Houghton Mifflin

CONTENTS

INTRODUCTION

In the introduction to *The Best American Comics 2011*, Alison Bechdel asks, "If you have spent a long time resisting the status quo—whether it's in art, society, or the political world—what happens when the status quo at last gives way? A universe of possibility opens up." Alison Bechdel stands in that universe of possibility. Thanks to the surprising success of her graphic memoirs, the Tony Award–winning musical adaptation of her graphic memoir *Fun Home*, and the honor of her being named a MacArthur Fellow, the status quo has been disrupted, and Bechdel has evolved from obscure queer culture icon to the mainstream's favorite lesbian cartoonist.

In all of her work, from *Dykes to Watch Out For* (*DTWOF*) to her tragicomics, and throughout all of her interviews, Bechdel directly addresses themes of sexual orientation, gender identity, representation of women, and heteronormative family life in an effort to fulfill her life's mission "to unceasingly excavate the potsherd of truth from the sediment of convenience" (Bechdel qtd. in Quinn) or, as she states early in her career, her "subversive plot to undermine the universal male subject" (Bechdel qtd. in Rubenstein). With her openly stated mission of disrupting the "masculinist" status quo, Alison Bechdel thrusts her personal experiences and life (as well as the lives of her family) into the political, public arena and likewise demonstrates that the political arena impacts people's lives on a personal level. From 1983 through today, Bechdel's body of cartooning embodies the feminist mantra that the personal is political and the political is personal.[1]

Examining personal relationships provides an understanding of cultural politics, and possessing a clearer grasp of societal politics allows for a more nuanced understanding of our personal lives; Bechdel demonstrates this in her cartoons. Additionally, Alison's work pushes cultural change, and thereby Bechdel is in a position to have her voice amplified because of the cultural change she created. In these simultaneous feedback loops (let's call them together the "Bechdel Feedback Loop"), the more Alison writes her queer life into queer comics, the more her cartooning creates cultural and political space

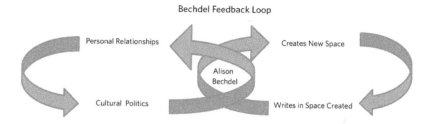

Bechdel Feedback Loop

for writing like hers, for voices and genres like hers, and the more room her cartoons create, the more space there exists for her work (and work like hers). This loop continues to this same end.

Bechdel's writing, drawing, cartooning pushes the boundaries of the status quo and opens up that universe of possibility for writers like herself, thereby opening up more cultural arenas for her own writing to abide. Her early work exists as a means of creating space for queer voices represented in media (albeit originally independent and queer presses); in creating avenues within the comic universe and popular culture for fringe voices, she begins to have more space for her own cartoons: as the years went on more and more presses sought out Alison to publish *DTWOF* within their pages. Residing within this now-available space for queer voices and comics that her early work makes possible, she pens *Fun Home*, which is successfully received and likewise creates even more room for her own and other queer voices and comic narrative. Through the opening of more cultural avenues in the mainstream for queer comics, Alison writes her next graphic memoir and so on. In this Bechdel Feedback Loop, her work simultaneously pushes cultural change and through that cultural change makes new spaces for her to write within. By forcing the status quo to budge, she creates a space where her own voice and the voice of those like hers can be heard (no longer silenced), allowing Alison Bechdel to move from obscure, underground lesbian cartoonist to mainstream memoirist.

Thrust into the spotlight, where she is now a household name and is recognized as she walks down the street, Alison Bechdel experiences notoriety that few comic artists ever achieve and that women comic artists have never seen. Prior to this, Bechdel broke upon the mainstream literary world with her graphic memoir *Fun Home: A Family Tragicomic* (2006), which made it on to the *New York Times* bestsellers list and many 2006 Best Books of the Year lists. Her position in this space was cemented by her subsequent graphic memoir, another tragicomic, *Are You My Mother? A Comic Drama* (2012). Before these successes, Bechdel elicited recognition and prominence in popular culture analysis through what has been coined the "Bechdel Test," which was taken

from one strip of her epically long-running comic strip *Dykes to Watch Out For* (1983–2008) and is used as a tool for judging representations of minorities in all aspects of popular culture (movies, literature, television shows, comics). And even prior to the wide acceptance and usage of the "Bechdel Test," her bimonthly *Dykes to Watch Out For* secured Bechdel's role in the comic world and queer community. Published regularly in nearly every lesbian, gay, and alternative magazine, newspaper, and journal, during its tenure *DTWOF* and its cast of characters reads as one part op-ed and one part Victorian novel (which were also published in serial form), making its author "the most popular American cartoonist who you've never heard of" (Rubenstein). However, the success of her tragicomic memoirs gave her notoriety and made her simply one of the most popular American cartoonists, moving her from a fringe cartoonist to a mainstream author.

Alison Bechdel's purpose to disrupt not only the largely homogeneous form of comics but also mainstream America's heteronormative ideals of family and gender leads her to the use of her own life and the lives of those around her, demonstrating a longstanding belief that the personal is political and the political is personal—a rallying cry of the feminist movement since the 1970s. In 2008, when discussing that notion, Bechdel joked, "That's my middle name—Personal is Political. Political is Personal," confessing that she did not "become a political person until I realized I was a lesbian. I was just this oblivious middle-class, white kid who didn't understand the structures of power or oppression or anything. My very existence became politicized for me, and that's what made me see all these things" (qtd. in Sollberger 2008). Because her "very existence" and personal identification as a lesbian fueled her politicism, her personal life as exposed in her work acts as a political force of change. By her making herself vulnerable and her family (and also to many extents the mainstream audience) uncomfortable, Alison Bechdel opens up her personal life to create an artistic and political voice for the often marginalized voices in fringe communities, moving from the already created space in the fringes of comics and culture, making her own coming-out and coming-of-age stories, the lives of her lesbian characters, and the genre of comics accessible and relatable to everyone, regardless of gender or sexuality. In this way she creates more room for her work to abide in the conventional populous.

In both of her memoirs, *Fun Home* and *Are You My Mother?*, Bechdel draws upon the connections between her own identity as a lesbian and her family relationships, and all of Bechdel's cartoons appear autobiographical to some extent. She reveals in the 1990 interview with Chris Dodge, included in this collection, that the principle character of Mo in *DTWOF* is approximately 30

percent Alison and her personality scapegoat. In another interview with the *Comics Journal*, she states, "Mo really is just sort of—me. Not in an autobiographical way. The strip isn't about my life. But Mo sort of looks like me, we have similar backgrounds." Bechdel even sets *DTWOF* in a fictional city that mirrors Minneapolis, where she lived when she started the strip. Despite her use of personal matter as a source throughout her career, Bechdel admits early on that she feels it is dangerous to let her work get too autobiographical, because it tends to get her into trouble. She echoes this sentiment a few other times throughout the litany of interviews. The space afforded by society thus allowed Bechdel to bring in and expose lesbian voices and communities to an audience unaccustomed to seeing these bodies or hearing these voices, but the status quo still foreclosed the possibility of expressing Bechdel's own personal life as a lesbian in the comic, in the written form, acknowledging that "there's something inherently hostile" in putting your own narrative out there (Bechdel qtd. in Burkeman). While Bechdel has pushed the mainstream appreciation for comic works and wider acceptance of queer voices, she notes her work is not yet done. She recognizes that she still needs to open up more realms and push more boundaries forward.

Throughout the first twenty years of her cartooning career, Alison Bechdel suffered from lack of recognition by mainstream audiences and comic sellers for her outstanding series *Dykes to Watch Out For*. While always drawn to cartooning, drawing, and storytelling, Bechdel penned her first panels of *DTWOF*, a single panel ("plate") that read "Marianne, dissatisfied with her morning brew: Dykes to Watch Out For, plate no. 27," in the margins of a letter to a friend (Rubenstein). Her marginalized comics about marginalized women literally started in the margins of a letter. Bechdel continued to write more of these plates, labeling them all *Dykes to Watch Out For*. A friend convinced her to submit some of them to *WomaNews*, a feminist newspaper where said friend worked and Alison herself volunteered. The publication ran two of her *DTWOF* cartoons in their 1983 Lesbian Pride issue. After doing the one-panel form for a year for *WomaNews*, Bechdel eventually shifted to strips, all of which depicted various aspects of lesbian lives and queer culture. Continuing under the name *Dykes to Watch Out For*, in 1987, the strip transitioned again, this time moving to the serialized format with recurring characters and community, which Bechdel continued until the 2008 hiatus and resumed with the strip's return in 2016. Through the single panels and separate strips, Alison created a space and a desire for a more continuous community narrative of queer folks in serialized comics. The consistent cast of dykes allowed Bechdel to demonstrate how these women (and women like them) moved through the

world, maintained personal relationships, and managed within a politicized society throughout the late 1980s, '90s, and the early 2000s; they were just like everyone else. The central character from 1987 forward is Mo (Monica) Testa. While originally claiming that Mo was only about 30 percent her, Bechdel later admits that Mo represents all of Alison's anxiety, cultural and political tendencies, interests, and loves; the character and the cartoonist even look alike and at one point both worked similar jobs at lesbian presses. In her interview with Ann Rubenstein in 1995, Bechdel described Mo as "young white middle-class dyke, vaguely based on me. I tried to disguise her by giving her longer hair than I have, and glasses, but the resemblance is still pretty apparent. Mo is the extreme embodiment of the lesbian-feminist social conscience." The very words Bechdel uses to describe Mo ("young white middle-class dyke") mirror the words Alison uses at other times to describe herself ("lesbian . . . white middle-class kid"). Through Mo and Mo's interactions with her world and friends, Bechdel addresses and responds to the politics of the time, while giving her audience a glimpse into a queer community; she uses their personal relationships to examine cultural politics, while displaying the power of such on these lesbian friendships. However, this commentary on cultural politics and its connection to the personal abides under a thinly veiled guise of fiction.

While the character of Mo looks like and most directly reflects Bechdel, each of the other women in this cartoon represents a piece of Alison. Alongside Mo exists a spectrum of characters; the most regular characters other than Mo are the struggling professor Ginger, the activist Lois, and the environmental lawyer Clarice. Once Bechdel acknowledged the slippage of her autobiographical content in *DTWOF*, she leaned into the curve, causing "the writing [to be] more complex. The relationships between the characters got more complex because I realized that I could write more like what my real life was like" (Bechdel qtd. in Quinn). *DTWOF* exposed many readers possibly for the first time to a complex, "real-life" lesbian experience and life they were not seeing in the heteronormative popular culture. The insider view into the close-knit realm of lesbian friends allowed Bechdel to also create the community of lesbians that she herself or other queer folks need. *DTWOF* existed as an outlet for Bechdel and as a safe space for her to process the world around her, demonstrating that understanding her own personal thoughts lent itself to understanding the culture and politics of the era, something she returns to in 2016. Throughout its first twenty-five-year stint from 1983 to 2008, Bechdel took on the consciousness of that era, exhibiting a queer family-like community walking through the Bush administrations, AIDS protests and walks, women and dyke marches, and the advancement of LGBTQ rights.

Because of the strip's sole focus on lesbian characters, the comic garnered criticism and pushback for not having any men characters. Bechdel addressed this directly by confronting what she refers to as "masculinist" ideas:

> When straight men write about women, the focus of the piece is the man. But a lot of the times when straight women write about men, the focus is still the man. It might be about what a jerk he is, but it's still about him. It's really hard not to write about men. I'm a lesbian writing a strip that has no male characters in it—and people somehow manage to construe even that as being a statement about men. My strip is not "not about men." It's simply "about women." (Bechdel qtd. in Rubenstein)

The exclusion of men in *DTWOF* represents a conscious choice to write about women only, telling the stories of women's, specifically lesbian's, experiences. She cartoons in this way, not to alienate readers, but rather to challenge readers to make the leap to identify with her characters, to identify with women, specifically with lesbians: "What I want is for men to read my work, and make the same leap of identity that we [women] have to make when we read one of the 99 percent of comic strips that star straight white men, boys, or animals" (Bechdel qtd. in Rubenstein). Her challenge to make that leap and to identify pushed the walls of conventions and asked readers to acknowledge the humanity of lesbians. The women of *DTWOF* come in all shapes and races, and as her strip was picked up by more and more presses over the years, Bechdel's still ever-growing readership demonstrates that many readers do in fact "make the leap of identity," proving a room indeed opened up for Bechdel's cartooning and community. Although later the strip does ultimately introduce male-identified characters, Bechdel's plot remains true, and her cartoon forever centers on queer voices.

Even in her production of *Dykes to Watch Out For*, her creation process echoes her dedication to using her personal experiences and opinions to discuss the politics of the time. For each strip she would go to "a foot-high stack of queer papers . . . the huge stack of magazines and newspaper," that she received every month, and while looking through them make "notes on what's going on in the world, and in the [queer] community, what the latest issue is, what people are wearing" (Bechdel qtd. in Rubenstein). She utilized a large chart to list all of *DTWOF* episodes on one axis, which is how soap opera writers organize their stories. Bechdel explores "the lives of the characters with what's going on in the world at large" (qtd. in Rubenstein), essentially writing a lesbian cartoon version of *Days of Our Lives*, a serial comic soap opera.

Like many cartoonists, when addressing the creative process, Bechdel continually answers the question of whether she works with words or images first. For her process with *DTWOF*, she expressed that she started with the words, "like writing a script or a screenplay," and after that she moved on to drawing the characters. She sketched them in roughly and "then it [was] just a process of tracing" (qtd. in Dodge). She worked with a light table and a large pad, and as technology evolved from the start of *DTWOF* in 1983, her process evolved with technological advances, moving into digital software; however, she remains consistently faithful to first the words and then the images. While she starts with the words, she admits that the words and the drawing cannot be separated out in a clear way because they are both equally "crucial to the story" (qtd. in Dodge). As technology evolves and changes her cartooning process, her sequence of words then images never waivers throughout her career to date (which this selection of interviews shows).

After writing the *DTWOF* strip for twenty-five years (1983–2008), Bechdel found herself "really ground down to a pulp by writing" and decided to take a break: a break that turned into a decade-long full stop. Alison announced her break on her blog (dykestowatchoutfor.org) before she told the presses that published her strip regularly: "I am going to take an unspecified amount of time off from the strip so I can get my next memoir (Love Life: A Case Study) [*Are You My Mother?*] written and drawn by the fall 2009 deadline." After stopping the cartoon, readers and publishers alike regularly asked her to return to it and asked her what her characters were up to, as if they were real people in Bechdel's life. She admitted many times that she did not think about *DTWOF* for years. She had created the space for queer culture and comics, and the world still wanted Alison to fill that space under the guise of fiction with these same queer voices in the same serialized form. Moving to her next project allowed for that now more accessible realm of possibility to be occupied by others, and let her move further into and more actively work to create and occupy the next space and phase of her work. This hiatus from *DTWOF* allowed Alison to pen other projects, which proved to be a successful move, giving her followers and many new readers *Are You My Mother?* and an anticipated third book-length project centered on bodily fitness and the inevitability of death.

However, after a seven-year "break" from *Dykes to Watch Out For* and after the election of President Donald Trump, Bechdel felt it once again necessary to expose the personal aspects and lives that were impacted by the political system, and so she returned to *DTWOF*. Bechdel wrote what she called at the time a "one off" return to the strip in November 2016. Once again, she "suddenly could hear and see them, and felt this tremendous need, for my own

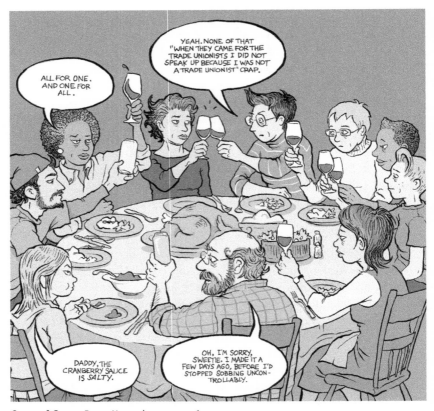

Cover of *Seven Days*, November 23, 2016

sanity, to bring them back, and try to write about what was happening in the moment. Because that's what I would use the comic strip for, myself, is to make sense of the chaotic world, and I never needed it more than last November [2016]" (qtd. in Swisher). She published the returning episode of her cartoon in her local, Vermont, independent newspaper *Seven Days* and on her own blog.

She explains being compelled back to the strip, to her long-time imaginary friends and their community:

> These people [characters in *DTWOF*] are just my friends too. My imaginary friends who I invented. Not that I don't have real friends, but in the real world my friends aren't this incredibly close-knit kind of community. I wanted to be in their company. . . . It just feels like I need that kind of solidarity right now. (qtd. in Zwillick)

Returning to her ever-useful ability to use her writing to process her feelings and thoughts about the world, Bechdel used the latest strips to help clarify her own emotions after the US presidential election of 2016 with her characters expressing their different opinions of the event: some expressing horror and utter despair, some mobilizing and rallying people in protest, some planning fall-out shelters, some noting that they should have and from here on out will pay attention a little more closely, and all of them gathering for Thanksgiving dinner. Based on what Bechdel states earlier in her career with regards to this strip, we understand each of these responses, each of these characters' reactions to be a reflection of Alison's own feelings, her way of figuring out what was going on in the world, in her community, and in herself.

With her original run of *DTWOF* (1983–2008), Bechdel created an arena for queer voices and queer comics; however, the new political climate threatened to silence those voices yet again and foreclose that open space by returning America to the way it was in the 1950s and 1980s and 1990s, when those voices were excluded. Her reboot of *DTWOF* acts to ensure that room still exists and fights to keep that opening accessible and acknowledged.

Despite her claims that the 2016 strip *DTWOF* was a one-off, Bechdel penned another episode "Postcards from the Edge" in April of 2017, releasing it again in *Seven Days* and on her blog. Accompanying this second "return" to her old friends, Alison writes, "We need stories to organize our thinking and consequently our actions. I need to tell these stories to organize my own thinking" (dykestowatchoutfor.org). While "Postcards from the Edge" works as "a way to stay sane" for Bechdel, it also alludes to the title of Carrie Fisher's well-known novel *Postcards from the Edge*, in which the main character says she feels like "something on the bottom of someone's shoes, and not even someone interesting." The characters in the *DTWOF* episode refuse to be something on the bottom of some uninteresting person's shoe: Alison refuses to be that. Instead, she uses this strip as a way to promote political involvement, a rallying cry of activism, by not only showing her characters engaging in a national campaign named "Ides of Trump," but also calling her readers to participate, asking them to get involved, make their voices heard to prove they cannot be flattened by the new political foot that has come down, proving that their voice is loud, numerous, and not ignorable. The 2017 "Ides of Trump" campaign asked people to write postcards to President Trump and mail those postcards to him at the White House. Bechdel depicts her characters' involvement in this political moment, in much the same way as she wrote them into other political moments over the strip's lifetime, such as the International Dyke March, the twenty-fifth anniversary of the Stonewall Riots, and the Gay Games, the

ways in which her original depictions opened up the universe of possibility for queer comics. However in "Postcards from the Edge," as the cartoonist, Bechdel directly addresses the reader and asks for her readers to engage in the political moment as well to engage politically and personally; an asterisk leads the reader to the margin, in the gutter of the strip, saying, "It can't hurt, right? The President, The White House, 1600 Pennsylvania Ave. NW, Washington, DC 20500 IDESOFTRUMP.COM," directing her community to act and to use their collective voices to defend their space and the hard-won progress they have gained over the last decades. Whereas she introduced and created the original *DTWOF* plate in the margins, Bechdel now returns to the margins. The first *DTWOF* was a fictional lesbian who moved from the margins into a larger cultural medium, and here we see Bechdel using her now more widely accepted voice to call from the literal margins/gutters that her panels' frames literally create and calls to protect the space her work has helped to create for queer voices within the mainstream. In this cartoon, Alison demonstrates how the strip, its characters, her message, and her genre work to both help her maintain her own sanity and to process what happens in the world, but also exhibits how *Dykes to Watch Out For* exists as political commentary and activism. And despite her repeated protestation in her early interviews that she is not an activist, Bechdel demonstrates how she uses her strip as a form of activism where her personal understanding and her own processing is political and is a political call to action.

By the early 2000s, *Dykes to Watch Out For* cemented Alison Bechdel's position as a queer, lesbian cartoonist. Her work brought her recognition in the queer and cartooning community. Queer presses and comic journals alike interviewed Alison during her early years before *Fun Home* success. In one such interview in 1995, Bechdel states, "I have no interest in speaking to the mainstream. I mean if my work ever got banal enough to make it into a mainstream newspaper, I hope someone would just put me out of my misery" (qtd. in Rubenstein). However, just over a decade later, her cartoons do appear in mainstream newspapers, due to her wildly popular graphic memoir *Fun Home: A Family Tragicomic* in 2006. She never imagined a world in which a platform for voices and genres like hers could exist, but "now here are my freaky, queer lesbian cartoons in the *New York Times*" (Bechdel qtd. in Sollberger 2008). Thankfully, her work avoids banality; instead the culture progresses with regards to acceptance of the LGBTQ community and with regards to acceptance of the comic form. The status quo that she expected would never change enough for her to see her comics in the mainstream (qtd. in Dodge) in her lifetime changed in such a way to actually make space for cartoonists like Bechdel.

Dykes To Watch Out For

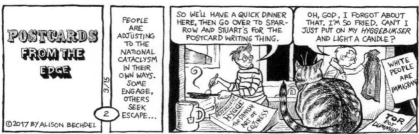

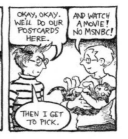

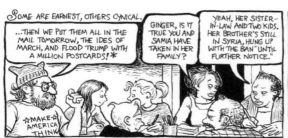

* IT CAN'T HURT, RIGHT? THE PRESIDENT, THE WHITE HOUSE, 1600 PENNSYLVANIA AVE. NW, WASHINGTON DC, 20500 **THEIDESOFTRUMP.COM**

"Postcards from the Edge," April 13, 2017, published in *Seven Days*

When discussing the greater acceptance of the queer community and answering the question of "Are gay people like everybody else now?" she names a sense of loss: "We are. And there's a sadness in that. I wanted to think we were special, more highly evolved somehow. I really believed that in my youth. Obviously that's ridiculous—we're the same as everyone else and it's amazing that that is being acknowledged" (Bechdel qtd. in Polgreen). "Being acknowledged" represents the shift in the status quo which gives way to great possibility, allowing Bechdel to break upon the mainstream audience without compromising her cartooning thematically or artistically. With the visibility of her work and the acknowledgement of her humanity in lesbian identity, her readers, even men and straight women, prove they can and do make the leap to identify with her comics in the very ways that Bechdel challenged them to in 1990.

On June 8, 2006, Houghton Mifflin made a leap of faith and released Bechdel's comic memoir *Fun Home: A Family Tragicomic* as the first graphic work that the press published. Their risk paid off. *Time* magazine named *Fun Home* "Book of the Year" in 2006, and Bechdel's first graphic memoir became a critical and popular success, appearing on many 2006 "books of the year" lists, winning numerous literary awards, and being translated into a dozen or more languages. Within eight months of its release and before the release of the paperback, more than 55,000 copies of *Fun Home* existed in print. In a *New York Times* review, the book was referred to as "a pioneering work, pushing two genres (comics and memoirs) in multiple directions" (Wilsey). Making these great strides in the genres presented no small feat for the author.

Alison Bechdel began writing and drawing *Fun Home* in 1998, seven years before its publication. She primarily worked from a polaroid and digital camera to take pictures of herself as each character in the cartoon frame. She drew from these photographs in Adobe Illustrator. Incorporating these self-portraits with old family photos, stock photos of places from Google Images, old letters, her childhood journal, maps of her hometown in Pennsylvania, as well as images of books like the *Odyssey* and *The Oxford English Dictionary*, Bechdel painstakingly created each page of her own story. The book hones in on connections between Bechdel's relationship with her own sexuality and her relationship with her father, her father's suicide, and his sexuality, showing as E. M. Forster puts forth that "personal relations are the real life, for ever and ever" (22). Set in the rural Pennsylvania town of Beech Creek, this debut memoir traces Alison's past in a nonlinear manner, while tying in other great works of literature. In a similar way as she uses a myriad of visual source materials, Bechdel references and alludes to other literary sources from authors such as F. Scott Fitzgerald, Marcel Proust, Henry James, Albert Camus, E. H. Shepard,

Colette, Kate Millett, and James Joyce. Recognizing the Joycean and Homeric references, Bechdel herself refers to *Fun Home* as "ostentatiously literary" (qtd. in Zuarino), which is possibly why it is embraced so vigorously by the literary community.

Bechdel used her graphic memoir to make the cartooning genre more widely accepted as a work of literature, pushing the boundaries of the literary canon to include the comic form. She detailed each panel so "that people [are] able to read the images in the same kind of gradually unfolding way as they're reading the text. . . . I want pictures that you have to read, that you have to decode, that take time, that you can get lost in" (Bechdel qtd. in Emmert). Bechdel's incredible visual details parallel her written text, which draws from traditional literature like F. Scott Fitzgerald and Proust. With both her drawings and words, Alison's coming-of-age and coming-out story blend and merge with her father's death and closeted sexuality. "Bechdel highlights moments of perception that offer illuminating forms of knowledge crucial to her own development as a woman, a lesbian, and as an artist" (Lemberg 129). In *Fun Home*, Bechdel shows how her own development in these arenas directly correlates with her father's own painful struggle of identity as a closeted queer in a pre-Stonewall era.[2] These two narratives snake together seamlessly as Bechdel weaves the written word with the visual medium as a means to move the status quo acceptance of the genres and the queer community.

Anyone and anything challenging the status quo creates cultural waves. And the backlash against *Fun Home* and Alison Bechdel reared its head alongside her mainstream praise. In October of 2006, the city of Marshall, Missouri, removed this graphic memoir, along with Craig Thompson's *Blankets*, from its public library shelves, citing that the works represented pornography with "frontal male nudity and explicit sexuality. Librarians claim that, because the book is illustrated, it will attract children" (Zuarino). Approximately six months after removing the books from their shelves, the library board voted to return the books into circulation. Missouri was not alone in attempts to censor the book; South Carolina state legislature pulled funding to the College of Charleston based on the inclusion of *Fun Home* on its freshmen reading initiative in 2013. Palmetto Family, associated with Focus on Family, a Christian fundamentalist organization, challenged the college's use of the graphic memoir, again citing that the book was pornographic. When the college refused to remove Bechdel's book, the state sanctioned the school by cutting their state funding from their reading initiative by over $50,000. Free speech organizations around the country railed, rallied, and raged against this sanctioning as censorship, sending out a letter co-signed by the National Coalition

Against Censorship, the ACLU of South Carolina, the American Association of University Professors, the Modern Language Association, the Association of College and Research Libraries, the American Booksellers Foundation of Free Expression, the Comic Book Legal Defense Fund, the Association of American Publishers, the National Council of Teachers of English, and the American Library Association (O'Connor). The South Carolina state senate restored the college's funding but set the condition that it be used to study *The Federalist Papers* and the United States Constitution (Kingkade). Bechdel expressed that the censorship of her work does not surprise her:

> It's sort of exciting too in a way because I feel it's very much about this moment of the evolution of the graphic narrative form where people don't know what to do with graphic novels, and there's this assumption that because they're illustrated they're going to draw children in. It's just part of the whole adjustment to what to do with these books and starting to think of them as a category. (qtd. in Zuarino)

One expects harsh criticism, backlash, and censorship of a book that pushes the boundaries of form and content, and Bechdel said the attempted bans were "a great honor" (Emmert). Bechdel recognizes these challenges to her work as the growing pains associated with disrupting the status quo in topic and text.

While some raised objections based on the adult narrative in comic form, others saw the medium perfectly befitting of the message: "Bechdel relies upon the visual elements of comics to bring the reader into her complex family history. . . . Drawing seems both to produce feelings and to produce a medium capable of expressing them" (Lemberg 129, 133). Through her penning, Alison opened up and exposed her family history, her identity, and queer politics in a medium that allowed the world to see her and hear her voice, to come face to face with her father and read his experience. For Alison (and for her readers), examining her personal relationships revealed an understanding of cultural politics of her father's Eisenhower era to the cultural politics at play in Bechdel's childhood and contemporary eras.

Two years after *Fun Home*, Alison Bechel released an anthology containing the majority of *Dykes to Watch Out For* strips. Released by Houghton Mifflin Harcourt, the book also included a twelve-page cartooned introduction by Bechdel, exploring her history with cartooning as a career, her resolve with the *DTWOF* strip, and delineating not only her creative process but her creative purpose, her "mandate" taken from the words of feminist essayist and poet Adrienne Rich's *On Lies, Secrets, and Silence*:

Whatever is unnamed, undepicted, whatever is omitted from biography, censored in collections of letters, whatever is misnamed as something else, made difficult-to-come-by, whatever is buried in the memory by collapse of meaning under inadequate or lying language—this will become, not merely unspoken, but unspeakable. (Rich qtd. in Bechdel *Essential* x)

Bechdel tells that after trying her hand briefly as a writer, her "mandate to speak the unspeakable" emerged in *DTWOF* as she depicted the essential, everyday "everydyke" experience, reflecting her "queer life back at [her]" and also offering for others "an antidote to the prevailing image of lesbians as warped, sick, humorless, and undesirable" (xv). Bechdel worked to make the queer community more visible, more accessible to everyone. However, according to Adrienne Rich in a letter to Alison, her work moves beyond showing the essential "everydyke" and explodes the very notion of the lesbian essentialism she originally thought to portray. Rather Rich says that *DTWOF* "explores our real humanity" (qtd. in Bechdel *Essential* xviii). While Bechdel took the mandate to "name the unnamed, to depict the undepicted, to make lesbians visible" in *Dykes to Watch Out For* and by all accounts succeeded in such, her graphic novel *Fun Home* and its follow-up *Are You My Mother?* explore "whatever is buried in the memory by collapse of meaning under inadequate or lying language" by diving into Bechdel's own memory to find words and provide meaning to her own experience as a member of the queer community, to resurrect her father's queer identity via a language that was unattainable or inadequate in his lifetime, and thereby to speak into existence her own memories of her childhood and relationship with her mother, by disrupting what she calls "the space-time continuum" via speaking the unspeakable truth of her memory and identity.

In the same introduction to *The Essential Dykes to Watch Out For*, Bechdel notes that "once you speak the unspeakable it becomes spoken! Conventional" (xviii), and the subsequent success of her second graphic memoir proves that queer comics (at least Bechdel's cartoons) breach the popular culture divide and reinforces that a space for these now exists. The voices and the genre are being accepted more freely. Originally entitled *Love Life: A Case Study*, this second memoir, *Are You My Mother? A Comic Drama*, debuted in 2012 published again by Houghton Mifflin. Where *Fun Home* focused on Bechdel's father and their relationship, using literary texts as a means of access and analysis, her second memoir hinges on her relationship with her mother, utilizing various psychoanalysis theorists (Donald Winnicott and Sigmund Freud) and other greats

(Virginia Woolf, Adrienne Rich, Mozart, Dr. Seuss, Alice Miller, and Molière). *Are You My Mother?* "is not so much the sequel to Alison Bechdel's captivating memoir *Fun Home*, as a maternal ying to its paternal yang" (Weschler). *Are You My Mother?* was not planned to be a sequel to *Fun Home*, but rather it just worked out that way, picking up where the latter left off (Bechdel qtd. in Samer) both personally and politically.

Like its counterpart, *Are You My Mother?* is told in nonlinear form with each of the seven chapters beginning with a dream of Alison's. The dreams act as a gateway into a blending of Bechdel's childhood memories of her mother and her explorations of a true self and authenticity. Even though Alison's mother expressed not wanting her daughter to write about her, Alison countered,

> Inevitably, if you're talking about relationships [which Bechdel believes all books are truly about relationships], you've got to talk about your mother because that's who your first relationship is with. . . . She really has forbidden me to write about her. I don't think you can really enforce that. Your mother is too much of your life not to be allowed to write about her. (qtd. in Zuarino)

Unlike writing about her father after his death which let Bechdel write without fear of her father's rejection of the personal content, Alison admitted that "it's really hard to write about my mom, knowing she's going to see it" (qtd. in Samer), but write about her she did. Bechdel's mother was diagnosed with cancer during the writing process of *Are You My Mother?*, changing Bechdel's concerns. While originally worried about her mother's reaction to Alison's second book, she was now concerned that her mother might never actually see the memoir. Her mother did live to see Alison's graphic full-length book about their relationship: "[She] saw the book about her. But I never knew if she was going to live to see it, which was very strange too" (Bechdel qtd. in Swisher). On the one hand, Bechdel acknowledged in 2010 that her mother forbade her to write about her, and on the other hand Alison recognized in 2015 that her mother never asked her to choose between her relationship with her mom or her art. Alison's mom understood that Alison "was going to tell the story. She would just live with it. It was not her story. It was my story" (Bechdel qtd. in Gross). Alison's mother, Helen Fontana Bechdel, died on May 14, 2013, and while *Are You My Mother?* is a memoir about Alison's mother, it is equally about Alison and her own process of writing and creativity, which, as she explains at the end of *Are You My Mother?*, is the gift her mother gave her; her mother taught her to be an artist.

Writing about her artistic writing process, her own sexual identity, and her relationship with her mother presented a huge undertaking. The memoir took Bechdel six years and approximately 4,000 reference photos to complete (MariNaomi). Her ambitious endeavor paid off in the form of public accolades and numerous awards, such as the Judy Grahn Award for Lesbian Non-fiction (2012), the International Forum for Psychoanalytic Education Distinguished Educator Award (2012), and the Erikson Institute Prize for Excellence in Mental Health Media (2015). The *New York Times* review noted that *Are You My Mother? A Comic Drama* "is as complicated, brainy, inventive and satisfying as the finest prose memoir" (Roiphe). The recognition of Bechdel's work and her second successful memoir moved the comic genre further into acceptance and understanding by the mainstream audience, and due to this acceptance of the form, *Are You My Mother?* garnered less backlash: the norm had shifted and access had been granted. The favorable popular response to her work embraced not just her queer subject matter but also the comic form:

> [The] innovative form lends itself to the subject: the graphic memoir can reproduce layers of thought and mimic strands of simultaneous life—the bursts of insight and memory that coexist with a humdrum moment like reading in bed with your lover, or arguing in the kitchen with your mother—in ways that pure prose cannot. . . . There's electricity to the form, to the interaction between pictures and words, between feeling and events, that gives Bechdel's cerebral introspection an immediacy and drama it wouldn't otherwise have. (Roiphe)

Scholars and book critics alike recognize that Bechdel's use of the comic genre matches her content perfectly, allowing her to more fully portray the emotions her story holds.

The contents of her graphic memoirs vary slightly in the shift from one parental relationship to the other; in the same way, her cartooning varies slightly as well. Bechdel's first graphic memoir was penned in black and white with a dash of turquoise. By contrast, *Are You My Mother?* is "still the two-color printing process . . . but the red is a spot color,[3] and there's a gray ink washed layer of shading that interacts with it in different ways, so there's actually a wide range of tones" (Bechdel in Terzian). Bechdel intentionally worked with this more sophisticated, nuanced coloring as a means of conveying the more complex relationship with her mother. Bechdel also varied panel vantage points in unusual ways in *Are You My Mother?*, ways that she does not usually employ in her other cartooning. Bechdel intentionally switched these up: "I started employing

these tricky, comic book angles like low angle shots looking down from the ceil-
ing—not randomly but with some sense of their emotional impact" (Bechdel
in Terzian). In this way, Alison Bechdel again utilizes a form that can and does
convey the emotional depth of her story; her form matches her content. And
the recognition and appreciation of both proves that Bechdel's work has yet
again pushed these forward, simultaneously creating space and residing within
the universe of possibility she and her work have brought forth.

Alison Bechdel wrote for motives beyond recognition of herself and her
form. Her reason for diving into the intricacy of her relationships and her fam-
ily life, namely that involving her parents, arose out of the desire to expose and
acknowledge that the personal dynamics at work in her home and in her and
her parents' lives were grounded in the political state; their struggles were not
simply their struggles, but were part of a larger cultural machine. "I could see
that their personal frustrations were not just personal, they were part of much
larger cultural and political structures. I just keep trying to understand those
and lay them bare" (Bechdel qtd. in Quinn). According to American novelist
Jonathan Safran Foer, Bechdel's work demonstrates "the most humane kind
of genius, bravely going right to the heart of things: why we are who we are."
Bechdel's ability and tenacity to cut to the quick of who and what humanity is
pushes the boundaries of the status quo. Alison finds it "so strange that [her]
work has been getting so much mainstream attention," positing that "this
sort of establishment recognition was never anything [she] envisioned when
[she] started doing [her] odd little subculture comic strip over thirty years
ago" (qtd. in Quinn). Her work no longer resides in the margins of society, and
she is proud of the work she is doing and has done, of the way her cartoons
have pushed the boundaries of queer and comic acceptability, of "drawing
comics about marginal people (lesbians) in a marginal format (comics)" (qtd.
in Quinn). Ultimately, her receiving a MacArthur Fellowship in 2014 demon-
strated publicly and proudly that Bechdel's work has meaning and solid footing
in a mainstream narrative and established convention.

By examining her work, from the single panels of and serialized *Dykes to
Watch Out For* to her graphic memoirs to her politically reactive *Dykes to Watch
Out For* reboots in 2016 and 2017, her readers confront Bechdel's challenges
to homogeneity, hegemony, and humanity. She places these objectives for
her audience in an "easy to read" format: "I want to work at a slightly finer
level of getting more information, more ideas, more complicated ideas into a
package that is still accessible, easier to read than not to read" (qtd. in Samer).
And Alison Bechdel's work and its success demonstrates that she has written
marginal voices in an underappreciated form in such a way that is "easier to

read than not to read" and thereby bringing these voices and this format into the hands, minds, and eyes of the mainstream.

When looking at the trajectory of Bechdel's cartooning, we are reminded of what Art Spiegelman said: "Comics are the battlefield that great issues are battled on." Alison battled and continues to fight for both queer voices and the comic genre to be recognized, accepted, and validated within the norm. In *Dykes to Watch Out For* from 1983 to 2008, Alison Bechdel portrays fictional queer voices. Voices such as these were largely absent within society. With these fictional lesbians, Bechdel tackled the political concerns of that era, ultimately creating a safer, more accepting arena for queer comics. That newly open, safer space freed Alison to move into writing about her own life and experiences as a lesbian, clearly articulating how examining her personal relationships led to a better understanding of cultural politics, which then led to an even better comprehension of personal relationships: the Bechdel Feedback Loop. Bechdel moves from the fictional queer community—a fictional "they"—in *DTWOF* to her real-life lesbian experiences—an autobiographical "me"—in *Fun Home* and *Are You My Mother?* In the mainstream's appreciation and acceptance of that autobiographical "me" voice, that personal dyke experience, the status quo gave way again under Bechdel's persistent weight, validating queer lives by recognizing Bechdel and her content and form. However, when that created creative room for queers and comics came under threat in 2016, Bechdel moved her work one step further, pushing that boundary yet again to make more space; this time she called for direct action as a means of retaining the safety of personal lives and experiences. This rallying cry, this battle cry took Alison's voice from her autobiographical "me" to a political and personal activist "we." Bechdel moves forward on the battlefield to embrace her work's overarching fight.

Alison Bechdel exemplifies her lifelong mission "to unceasingly excavate the potsherds of truth from the sediment of convenience." She vows to never quit digging the scattered, shattered pieces of truth from the dregs of everyday life and ease, to relentlessly pull up and bring out the hidden deeper meaning that lies buried in that which we do without effort, without thought, that which is buried in plain sight, unearthing what lies beneath our comfort zone, challenging the mainstream to make "this new space in the world" (qtd. in Joost). Bechdel's ultimate goal then remains to disrupt the status quo and open up a universe of possibilities for queer voices and comic visions. And Alison Bechdel's work will continue to do just that.

In this compilation of interviews with Alison Bechdel, her mission comes clearly into view and demonstrates it linear trajectory from 1990 to 2017. While

reading these interviews Bechdel's audience will see changes in her creative process and her stance on writing about her family; however, readers will not see a change in her purpose for writing. This anthology includes some of the earliest interviews with Alison, such as a 1990 interview with Chris Dodge for a public access show called *Northern Lights* in Minneapolis, Minnesota, as well as interviews with small comic presses in the mid- to late 1990s and 2000s. As Bechdel's mainstream popularity increased, so did the number of accessible interviews. Rather than focusing this book's attention on the larger print publications, I chose interviews from smaller presses with whom Alison spoke intimately (such as her local liberal newspaper, *Seven Days* out of Burlington, Vermont, and feminist bloggers). In the 2008 interview with Eva Sollberger, readers should note that Bechdel says a line that made it into the musical production of *Fun Home*, a line that was not in the book *Fun Home*, a line that was only spoken in that interview. I also intentionally included several interviews that until now have only been available in a video or audio format, making them more accessible to a variety of readers via the print format: this includes the first interview and the final two interviews from more mainstream audio sources. Many interviews from larger presses and mainstream sources are not included in this collection but are listed in the bibliography. Many of these large press interviews reinforce the messages and mission that push Alison's cartoons and that she clearly articulates in the included interviews as well. I encourage anyone interested in Alison Bechdel and her work (anyone reading this) to explore those interviews not included here to supplement this anthology of Bechdel interviews.

ACKNOWLEDGMENTS

Most obviously, first thanks goes to Alison Bechdel, whom I have never met, but who responded to my emails and wished this project well. Thank you for graciously giving your permission to use your most recent *Dykes to Watch Out For*. Thank you for writing queer voices into comics, so that folks like me saw and continue to see ourselves in our favorite medium, and so that the mainstream hears "loud and queer" the more marginalized voices. Thank you for repeatedly demonstrating that the personal is political and the political is personal. Thank you for holding true to your mission and continuing to draw cartoons.

Of all the people I have met and of all the people I have never met, the biggest thanks goes to my partner in madness, Jeremy, who helps me create space to write, who forces me to finish the projects I start, who loves me in spite of

or because of (I am still unclear which) my love of comics. I must thank my kids who "let" me shut myself in my library and who are discovering their own love of reading comics because comics are awesome. Mommy is proud of you.

This project exists due to a large number of people I have never even laid eyes on, but who corresponded with me tirelessly, responded to my relentless requests, answered my emails, and tolerated my questions. Thank you to those of you on the comic listservs and the fan sites who geeked out with me over this project and helped me in attempts to find older, offline interviews. A specific thanks needs to go to the women at *Seven Days*, Pamela Polston and Eva Sollberger, who continue to publish *Dykes to Watch Out For* and who put me in touch with Alison Bechdel. Thank you to all of the interviewers who ask the right questions, the wrong questions, the hard questions, and the funny questions. This collection of interviews could not have been realized without the permissions granted to use interviews and images by all the copyright holders, and I am eternally grateful.

I would like to thank Northern Virginia Community College–Alexandria campus's English department for acknowledging that comics are indeed part of the literary canon. I need to thank my colleagues and friends, Mike Amey and Amy Coran, for co-teaching our free "Spoilers" class, creating an arena to bring Bechdel and comics to a new (older) community of readers. Thank you to Gwen McCrea and Owen Britton for keeping me realistic and on task. Thank you, Leah Perry, for loving and encouraging me personally and academically, for seeing and hearing me. I want to thanks cultural studies and comic studies programs worldwide for validating the notion of comics, graphic novels, and cartooning as academic subject matter and for accepting and advocating for queer voices in academia.

And a very special thanks to local comic book stores for staying open, supplying comic geeks like me with happiness, and to the queer presses (both print or online) for continuing to create a sense of community.

RRM

NOTES

1. "The personal is political" emerged out of second-wave feminism via an essay with that very name by Carol Hanisch, which was originally published in *Notes from the Second Year: Women's Liberation* in 1970 (Hanisch). With this context, "'political' was used here in broad sense of the word as having to do with power relationships, not the narrow sense of electoral politics" (Hanisch).

2. In the 1950s and 1960s, the gay community in America experienced not only antigay cultural norms but antigay legal systems where openly gay men faced not only being ostracized but also being imprisoned. In 1968, the NYPD raided the Stonewall Inn, which was known as an establishment openly welcoming gay and trans people. In response to the raid, spontaneous, violent demonstration broke out. The Stonewall Riots (also known as the Stonewall Rebellion or the Stonewall Uprising) are considered by many to be the most important and pivotal moment in the history of the fight for LGBTQ rights.

3. According to Print Outlet (www.printoutlet.us), "In offset printing, a spot color is any color generated by an ink (pure or mixed) that is printed using a single run."

WORKS CITED AND FURTHER READING

Ashbrook, Tom. "Alison Bechdel: 'I Just Became A Professional Lesbian.'" *On Point: WBUR*. Baltimore, MD. April 13, 2015.

Bechdel, Alison. *Are You My Mother? A Comic Drama*. Houghton Mifflin Harcourt. New York, 2012.

Bechdel, Alison. *The Essential Dykes to Watch Out For*. Houghton Mifflin Harcourt. New York, 2008.

Bechdel, Alison. *Fun Home: A Family Tragicomic*. Houghton Mifflin Harcourt. New York, 2006.

Bechdel, Alison. *The Indelible Alison Bechdel: Confessions, Comix, and Miscellaneous Dykes to Watch Out For*. Firebrand Books. Ithaca, New York, 1998.

Bechdel, Alison. "Introduction." *Best American Comics 2011*. Ed. Neil Gaiman. Houghton Mifflin Harcourt. New York, 2011.

Burkeman, Oliver. "A Life Stripped Bare." *The Guardian*. October 16, 2006.

Colins, Sean T. "Alison Bechdel on 'Fun Home's' Tony-Award Triumph." *Rolling Stone*. June 18, 2015.

Dodge, Chris. "Interview with Alison Bechdel, Writer and Lesbian Cartoonist." *Northern Lights and Insights—A Look at Minnesota Books and Writers*. Hennepin County Library. March 14, 1990.

Emmert, Lynn. "Life Drawing: The Alison Bechdel Interview." *Comic Journal*. Issue 282, No. 36. Seattle, WA. August 2007.

Farley, Christopher. "Alison Bechdel, Author of 'Are You My Mother,' Interview." *Wall Street Journal*. May 2, 2012.

Fisher, Carrie. *Postcards from the Edge*. Simon & Schuster. New York, 2010.

Forster, E. M. *Howards End*. Dover Publications. New York, 2002

Gross, Anna. "Alison Bechdel." *A.V. Club*. October 10, 2011.

Gross, Terry. "Lesbian Cartoonist Alison Bechdel Countered Dad's Secrecy by Being Out and Open." *Fresh Air: NPR*. August 17, 2015.

Joost, Wesley. "Sing Lesbian Cat, Fly Lesbian Seagull: Interview with Alison Bechdel." *The Guardsman*. May 15, 2000.

Kingkade, Tyler. "These College Budget Cuts Risk Violating the First Amendment, State Lawmakers Are Warned." *Huffington Post*. New York. March 18, 2014.

Lancaster, Brodie. "Why Can't I Be You: Alison Bechdel." Rookiemag.com. April 17, 2014.

Lemberg, Jennifer. "Closing the Gap in Alison Bechdel's *Fun Home*." *Women's Studies Quarterly*. Vol. 36, No. 1 & 2. Spring/Summer. 129–140.

MariNaomi. "The Rumpus Interview with Alison Bechdel." *The Rumpus*. May 30, 2012.

O'Connor, Acacia. "Letter Urges S.C. Legislature to Restore Funding to Universities with LGBT Curricula." National Coalition Against Censorship. March 25, 2014.

Polgreen, Lydia. "Alison Bechdel Misses Feeling Special." *New York Times Magazine*. May 13, 2015.

Quinn, Annalisa. "Book News: A Q&A with Alison Bechdel, Cartoonist and MacArthur Winner." *The Two-Way: Breaking News from NPR*. September 17, 2014.

Roiphe, Katie. "Drawn Together: *Are You My Mother* by Alison Bechdel." *New York Times Book Review*. April 27, 2012.

Rubenstein, Anne. "Alison Bechdel Interview." *Comics Journal*. No. 179. August 1995.

Samer, Roxanne. "A Conversation with Alison Bechdel." *Gender Across Borders*. February 23, 2010.

Sollberger, Eva. "Stuck in Vermont—Alison Bechdel." *Seven Days*. SIV 109. December 13, 2008.

Sollberger, Eva. "Stuck in Vermont—Alison Bechdel." *Seven Days*. SIV 396. April 17, 2015.

Swisher, Kara. "Alison Bechdel, Onstage, and on Recode Decode." *Recode Decode*. February 8, 2017.

Terzian, Peter. "Family Matters: Alison Bechdel on 'Are You My Mother?'" *Paris Review*. May 9, 2012.

Weschler, Lawrence. "Editorial Review of *Are You My Mother? A Comic Drama* by Alison Bechdel." Amazon.com. June 7, 2018.

"Writers on the Fly: Alison Bechdel." Iowa City UNESCO: City of Literature. December 27, 2010.

Zuarino, John. "An Interview with Alison Bechdel." *Bookslut*. March 2007.

Zwillich, Todd. "In the Trump Era, Comics Become a Protest Tool." New York Public Radio. December 1, 2016.

CHRONOLOGY

1960 Alison Bechdel is born in Lock Haven, Pennsylvania, to Bruce Allen Bechdel (1936–1980) and Helen Augusta Fontana (1933–2013) on September 10. Bechdel grows up in nearby Beech Creek, Pennsylvania, with her two brothers: Bruce "Christian" Bechdel II and John Bechdel.

1977–79 Bechdel leaves high school a year early and attends Simon's Rock College (now Bard College at Simon's Rock).

1979 Bechdel earns an associate's of arts degree from Simon's Rock College and transfers to Oberlin College. While at Oberlin College, Bechdel comes out as a lesbian. Years later she writes a six-page cartoon describing her process of coming out at Oberlin College. Bechdel's understanding of her own sexuality and her identity as a lesbian factor heavily in all of her work.

1980 Bruce Allen Bechdel dies when hit by Sun Beam Bread truck. His death is ruled an accident; however, Alison Bechdel believes his death to be a suicide. Bruce Bechdel's untimely death, his closeted homosexuality, and his relationship with his house and his family later inspire Alison Bechdel to write *Fun Home*.

1981 Despite a great deal of familial unrest during her time at Oberlin College, Bechdel earns a bachelor's of arts degree in studio arts and art history.

1981–85 Bechdel moves to Manhattan. After applying to and being rejected from graduate programs at multiple art schools, Bechdel works as a word processor and in a number of offices in the publishing industry in New York City.

1983 Bechdel creates her first panel of *Dykes to Watch Out For*, which read "Marianne, dissatisfied with the morning brew: Dykes to Watch Out For, plate no. 27." She submits her first *Dykes to Watch Out For* single panel to *WomaNews* and has it published in their June 1983 issue.

1985 Bechdel syndicates *Dykes to Watch Out For*. DTWOF begins appearing bimonthly in multiple gay, lesbian, and alternative presses across the

United States. *DTWOF* originally consists of unconnected strips and no serialized storyline. "The Rule" strip of *Dykes to Watch Out For* appears in print. This strip (found on page twenty-two of the original *DTWOF* collection released the following year) is the basis for what later becomes known as the Bechdel Test. Picked up nearly twenty years after it was penned, the cartoon strip inspires film students and feminists alike, who originally refer to "The Rule" as the Mo Movie Measure, despite the fact that the character of Mo is not in the strip and is not even created at the time this is penned. In "The Rule," Bechdel depicts two women who discuss going to the movies. One of the women says she will "only go to a movie if it satisfies three basic requirements. One, it has to have at least two women in it who, two, talk to each other about, three, something besides a man." These three qualifications become known twenty years later as The Bechdel Test and are now used to evaluate representation of women in films and all creative forms of media, including comics and cartoons. Bechdel later makes clear that she cannot take credit for the idea of "the rule." She says that, when she was having trouble coming up for an idea for her strip that week, she stole this concept from her friend, Liz Wallace, whose name is on the marquee behind the two women in the strip. Despite Bechdel's correction, "The Rule" continues to be referred to as "The Bechdel Test."

1986 Through Firebrand Books, Bechdel publishes her first collection of *Dykes to Watch Out For*. According to Bechdel, Nancy Bereano nearly begs Alison to let her publish this compilation of *DTWOF* early panels and strips. This first collection includes individual strips and miscellaneous works.

1986 Alison Bechdel leaves New York, moves briefly to Massachusetts, and then settles in Minneapolis, Minnesota.

1986–90 While living in Minnesota, Bechdel works as a production manager for gay and lesbian newspaper *Equal Times*. It is based on her experience at this press that she later writes *Servants to the Cause*.

1987 Two years after beginning her comic strip, Bechdel introduces regular characters to *Dykes to Watch Out For*, focusing on a small subcultural group of queer friends. Her main character from this point forward is a politically active, feminist lesbian named Mo (short for Monica) Testa. Other regular characters include the struggling professor Ginger, the activist Lois, and the environmental lawyer Clarice. *DTWOF* develops a large cult following.

1988 Based on her own personal experience in the industry, Bechdel pens a short-lived strip for *The Advocate*. The strip was titled *Servants to the Cause* and centers on the staff of a queer newspaper. Continuing with Firebrand Books, Bechdel publishes *More Dykes to Watch Out For*. Approximately halfway through this anthology, the strip's recurring characters first appear.

1990 Due to the success of *Dykes to Watch Out For*, Alison Bechdel quits her day job and begins working full-time as a cartoonist. She leaves Minnesota and moves to Burlington, Vermont. A third compilation of her comic strip entitled *New, Improved! Dykes to Watch Out For* comes out with Firebrand Books. In this book, Bechdel starts to include graphic novellas at the end of each collection.

1992 Bechdel publishes *Dykes to Watch Out For: The Sequel* (Firebrand Books). Alison meets and begins dating Amy Rubin.

1993 Bechdel publishes her fifth published compilation, *Spawn of Dykes to Watch Out For* (Firebrand Books). Bechdel's additional work at the end of this book advances the plot of *DTWOF*. At the end of *Spawns of DTWOF*, the birth of Rafi appears; this did not appear in the serialized strip.

1995 In this compilation, *Unnatural Dykes to Watch Out For* (Firebrand Books), the backstory of how the main characters originally met is exposed via flashbacks.

1997–98 Alison Bechdel publishes two more compilations of the syndicated, thirteen-year-old cartoon. These books are *Hot, Throbbing Dykes to Watch Out For* and *Split-Level Dykes to Watch Out For* (Firebrand Books).

1998 *The Indelible Alison Bechdel: Confessions, Comix, and Miscellaneous Dykes to Watch Out For* (Firebrand Books) is published the same year as *Split-Level Dykes to Watch Out For*, but is not a chronological compilation as her other books have been. *The Indelible Alison Bechdel* contains strips that have previously been published in calendars (the majority of which also came out through Firebrand Books), a thorough timeline for the *DTWOF* up to that point, and a "tour" of the "factory" where Bechdel produces her cartoons. Bechdel begins her seven-year project of writing *Fun Home*. She largely worked from personal childhood memorabilia and photographs: old family photographs and posed photographs of herself as different characters in different poses.

2000 Firebrand Books releases *Post-Dykes to Watch Out For.*

2003 Firebrand Books releases *Dykes and Other Carbon-Based Life-Forms to Watch Out For.*

2004 Alison marries her girlfriend of twelve years, Amy Rubin, in San Francisco, California, in 2004. The couple remains married for only two years and divorce in 2006. They live the entirety of their marriage in Vermont.

2005 Bechdel publishes *Invasion of the Dykes to Watch Out For* with Firebrand Books.

2006 After seven years of writing and drawing, Alison Bechdel publishes *Fun Home: A Family Tragicomic* with Houghton Mifflin. *Fun Home* is the first graphic novel published by Houghton Mifflin. Set in her rural Pennsylvania hometown, the book hones in on connections between Bechdel's relationship with her own sexuality and her relationship with her father, her father's suicide, and his sexuality. *Fun Home* meets with great success both popularly and critically. It spends two weeks on the *New York Times* Best Seller list. *Time* magazine names it "Book of the Year" for 2006. *Fun Home* is also awarded National Book Critics Circle Award in the Memoir/Autobiography category in 2006.

2007 *Fun Home* continues to bring home awards: GLAAD Media Award for Outstanding Comic Book, Stonewall Book Award—Israel Fisherman Non-fiction Award, Publishing Triangle—Judy Gahn Nonfiction Award, Lambda Literary Award in the Lesbian Memoir and Biography category, and Eisner Award for Best Reality-Based Work.

2008 *Essential Dykes to Watch Out For*, the ultimate collection, is released by Firebrand Books. This anthology collects the majority (but not the entirety) of the *DTWOF* strips. *Essential Dykes to Watch Out For* includes a twelve-page cartooned introduction by Bechdel, delineating her history drawing and creating the strip. The same year as *Essential Dykes to Watch Out For*, on May 10, Bechdel writes to her blog followers on dykestowatchoutfor.com, before telling the papers that published her strip, that she is "going to take an unspecified amount of time off from the strip [*Dykes to Watch Out For*] so I can get my next memoir (Love Life: A Case Study) [*Are You My Mother?*] written and drawn by the fall 2009 deadline." *DTWOF* runs one last episode in its regular places. Bechdel refers to her "time off" as a "sabbatical," which is what the final serialized episode is about. Bechdel penned

DTWOF in one form or another regularly for twenty-five years before "retiring" the strip. In the fall of 2008, Bechdel writes a short graphic essay about her father in the "Fathers" issue of *Granta: The Magazine of New Writing*, Issue 104.

2009 *Essential Dykes to Watch Out For* receives Ferro-Grumley Award for LGBT Fiction.

2011 Along with Jessica Abel and Matt Madden, Bechdel acts as guest selector and creates *Best American Comics 2011*, edited by Neil Gaiman. Bechdel writes the introduction.

2012 What Alison Bechdel originally called *Love Life: A Case Study* ultimately is published as *Are You My Mother? A Comic Drama* by Houghton Mifflin. Though not originally planned as such, Bechdel's second graphic memoir reads as a follow-up, companion piece to *Fun Home*. *Are You My Mother?* focuses on her distant relationship with her mother, Helen Augusta Bechdel. Alison Bechdel is awarded the Bill Whitehead Award for Lifetime Achievement from Publishing Triangle.

2013 Bechdel receives the International Forum for Psychoanalytic Education Distinguished Educator Award and the Judy Grahn Award for Lesbian Non-Fiction for *Are You My Mother?* On May 14, Alison Bechdel's mother Helen Fontana Bechdel dies of cancer in her home in Bellefont, Pennsylvania. In September, *Fun Home: The Musical* opens off-Broadway at the Public Theater to great reception and reviews. Lisa Kron and Jeanine Tesori adapt Bechdel's memoir *Fun Home* into an award-winning musical. *Fun Home: The Musical* opens on Broadway at the Circle in the Square in April 2015 and wins five Tony Awards.

2014 On June 9, the *New Yorker* publishes a Sketchbook piece by Bechdel for their love-stories-themed Summer Fiction Issue. Bechdel's strip is "My Old Flame: Gradual Impact," and begins with "I once had a lovely affair with someone who was kind, beautiful, smart, interesting, sane, and available. I broke it off after a few weeks. What the fuck was my problem?" For the summer, Bechdel takes part in a six-week artists residency in Umbria, Italy, at a castle called Civitella Ranieri. During her residency, she works on cartoons in ink and life-size figure drawings in charcoal. At the age of fifty-four, Alison Bechdel is named a MacArthur Fellow. As one of the twenty-one recipients of the year's MacArthur Foundation stipend, Bechdel receives a $625,000 "genius" grant for "changing our notions of the

contemporary memoir and expanding the expressive potential of the graphic form."

2015 An art installation spanning from her early *Dykes to Watch Out For* strips and more obscure pieces like "Oppressed Minority Cartoonist" to her work from *Fun Home* and *Are You My Mother?* opens at the Institute for the Humanities Gallery at the University of Michigan and runs through February. In response to *Are You My Mother?*, Bechdel is awarded the Erikson Institute Prize for Excellence in Mental Health Media. Bechdel marries Holly Rae Taylor, a painter, after living with her for seven and a half years. They live in Bolton, Vermont, outside of Burlington.

2016 After putting down *Dykes to Watch Out For* abruptly in 2008, Bechdel writes and publishes a one-off strip entitled "Pièce De Résistance" in a local Vermont newspaper, *Seven Days*. In the cartoon, Bechdel voices her own shock and response to the 2016 election of President Donald Trump. Regarding her return to *DTWOF*, Bechdel says, "In the wake of the election, I just had to go back to it; I had to write about it through these characters who I knew so well from the old days" (qtd. in Zwillick).

2017 Again in *Seven Days* and on her blog, on March 14, Bechdel pens another strip of *Dykes to Watch Out For* entitled "Postcards from the Edge." Accompanying the strip, Bechdel says on her blog that she plans "to continue doing these [*DTWOF* strips] on an occasional basis as a way to stay sane." The strip exists as part of a national campaign called the Ides of Trump set for March 15, 2017, designed to bombard the president with postcards.

ALISON BECHDEL: CONVERSATIONS

Interview with Alison Bechdel: Writer and Lesbian Cartoonist

CHRIS DODGE / 1990

From *Northern Lights and Insights—A Look at Minnesota Books and Writers*, March 14, 1990. Reprinted with permission.

Chris Dodge: Your comic strip, Alison, is published in newspapers all over the country, and I know of at least one in Canada. Your third compilation of comic strips is due to be published soon by Firebrand books. At a time when comic strips, according to Bill Watterson, author of *Calvin and Hobbes*, are poorly drawn, and I quote, "simpler and dumber than ever," your strips, and I don't want you to blush, are drawn with skill, sensitivity, good humor, and integrity. They feature humane, three-dimensional characters, articulate text, and they produce, at least in me, a feeling that is warming, inspirational, and liberatory. Alison's strip is called *Dykes to Watch Out For*. Its main characters are lesbians and its publication is confined, except with a couple of exceptions, to the gay and lesbian presses, despite its potential accessibility to all readers. Do you foresee a time when *Dykes to Watch Out For* is in the *Star Tribune* or the *Pioneer Press Dispatch*?

Alison Bechdel: Well, no . . . I don't have any plans for it in my lifetime. But I am excited because two small leftist papers, not specifically gay, have just subscribed to the strip, so it's like I'm starting to reach this audience that's not exclusively gay and lesbian. And that's great. That's really what I'd like to do to reach more people. But, I mean, I doubt if it's going to be the *Star Tribune*.

Dodge: You're working that direction though?
Bechdel: Yeah, I'd like to. My ultimate goal would be to get in the alternative weeklies, the *City Pages*, the places where Lynda Barry's work runs, those kind of papers.

Dodge: We're living in a climate in which we've got billboards posted in St. Paul for candidates for public office stating, "Straight Power."
Bechdel: [sighs] Yes.

Dodge: And a climate in which books are published that baldly state that AIDS is a form of self-punishment. Is your strip part of a solution do you see?
Bechdel: Well, I would hope so. And then of course, there's all the NEA stuff and Jesse Helms censoring anything that's homoerotic.

Dodge: But it seems to me that, in my reading of your strip, it works on a couple of different levels. One of them being, it's not specific to lesbian issues. There are topics dealt with that can be understood by anybody; they're universal. They're dealing with relationships, no matter what the relationship is, they're dealing with living with people, they're dealing with safe sex, they're dealing with, and one of my favorite stories is, the fear of dancing.
Bechdel: [laughs]

Dodge: [laughs] And they're things where you don't have to be coming from a lesbian experience to understand.
Bechdel: Well that's what I'd like to think, and hope that people can, from different backgrounds, can connect with this thing. I think that some people do and that's wonderful, but, you know, I look at the daily funnies, and all of those, almost all of those cartoons focus on white male characters. Whether they're animals or people, they're perceived to be these white men.

Dodge: They're white men . . .
Bechdel: Or boys . . .

Dodge: And the point I wanted to bring up was that your characters are not only multiethnic, Clarice is a black woman obviously, there are Jews, there are people of different shapes and sizes, ages, and it's not the stereotypical . . .
Bechdel: That just as all those people, all the women and black people and Jews all make this kind of leap of identity to read and understand *Garfield*, and we do, you know, that it's not asking a lot to expect white, Christian, mainstream men to also make that kind of leap. I think that would be wonderful. People who can lead a pretty safe and unthreatened life and don't have to think about diversity if they don't want to, I think it'd be great to see them doing that.

Dodge: But first you've got to get into the places that people are going to read.
Bechdel: Right.

Dodge: There's frankly probably about a quarter of that many straight people who read *Equal Time*, which is a shame because it's a great publication. And now that I mention *Equal Time* and before we go into your comic strip, I will also mention that you in your day job—
Bechdel: Yeah, my day job [laughs] . . .

Dodge: —are a production coordinator for *Equal Time*. Do you want to tell a little bit about what that entails?
Bechdel: Ah, well, it's a . . . *Equal Times* comes out every two weeks and it's a community newspaper for lesbians and gay men. And my job is doing all the key lining and layout production and doing the physical part of the paper.

Dodge: It's a really attractively designed paper. It's really easy to read.
Bechdel: Oh [laughs].

Dodge: I mean honestly. It looks good.
Bechdel: People don't usually notice that. I mean a newspaper's a newspaper.

Dodge: Well, I notice it.
Bechdel: Well, thank you.

Dodge: And another periodical you have a say in, and I don't know exactly what you can tell me, is *Art Paper*. You're on the artist advisory board.
Bechdel: Right, the artist advisory panel. And that's a panel of six artists in the community who kind of critique *Art Paper* and talk about directions for it to move in. Right now, we're going to be talking about changes to make in the format or the structure over the summer.

Dodge: Let's talk a little bit more about the content of your strip *Dykes to Watch Out For*. I mentioned that there were so many issues that I relate to, that are not directly related to the lesbian experience. On the other hand, there are issues that are directly addressing things like coming out and identity, and public perception, like mistaken gender. There are a number of mistaken gender stories. The idea of lesbian community and friends and interrelation-ships. And there's sex in some of your comic strips and it's really tastefully

done, but it's not hot, it's neither explicit but it's getting there. And in one of your *More Dykes to Watch Out For*, you describe it as a "slightly erotic story" or something like that.

Bechdel: Right.

Dodge: That's a part of the strip.

Bechdel: Yeah, I think it's really important to show all parts of our lives, you know. I don't know. I just think it's important to be open about stuff. I don't know exactly what else to say about that.

Dodge: Well, it's good. I'm fascinated by the heck of a lot of magazines I read and get them in the mail, and I see your stuff everywhere. I see it in *Hot Wire*, which is a magazine of women's music. I know you did a t-shirt for them. And I hear that Alison Bechdel did a drawing for "this cause." I see you in *Equal Times*, not only with your strip but in your—in advertising sometimes. And all over the country. My perception is "Wow, she's a star!"

Bechdel: [laughs]

Dodge: But does it feel that way?

Bechdel: Well, no, not really. I mean in the gay community across the country is really kind of a, well of course, it's really diverse, and there's millions of people I certainly will never even meet, but there's a way where it's very closely knit. And that this gay and lesbian press, this network of newspapers, a lot of them carry the strip, so it's like I am. I'm read all over the country, but only part of a small community in a way. I don't know.

Dodge: I'm curious as to how you go about marketing it, the strip.

Bechdel: Actually, a lot of places recently have been approaching me. At one point I did a mailing.

Dodge: I had the sense that that might be the case.

Bechdel: Yeah.

Dodge: So you're not really actively doing it?

Bechdel: I mean I should be, but I don't have time. I'd like to. I know there's lots more papers out there that I'd like to get in. So that's one of my projects.

Dodge: Speaking of projects, is there anything? We can mention that not only do you have *Dykes to Watch Out For*, but you've got *Servants to the Cause*.

Bechdel: I do another comic strip for *The Advocate*, which is a national gay news magazine. And that's a strip about a gay and lesbian newspaper. I kind of draw on some of my own work experience.

Dodge: And I meant to ask you how autobiographical *Dykes to Watch Out For* is. Because I've had the sense . . . As a matter of fact, there's a gay newspaper in one of the stories in there, and Mo is involved, *Gayly*.
Bechdel: Oh yeah! I forget. That was a long time ago. She used to work for one. When people ask me how much of Mo is me, I usually come up with this figure of 30 percent. I don't know exactly how, but I don't like to identify too heavily with her. But yeah, she's basically like me. And it's also dangerous to get too autobiographical in my work because it can upset people. I've gotten in trouble for using stuff that they've said. People who think I'm basing a character on them, which I actually haven't done, but sometimes people think I do.

Dodge: Sure. I'm losing track of a thought I just had. . . . Mo and Lois and Clarice and Toni are on the cover of *More Dykes to Watch Out For*. They're characters who've been around for how long?
Bechdel: I first started using these guys in the winter of, January of 1985, so five years now. No, no, it was '87. It was 1987. So it's only been three years that I've been working with them.

Dodge: And that was where that first was published? Was that *Equal Times*?
Bechdel: Ah, yep, uh-huh.

Dodge: The first *Dykes to Watch Out For*?
Bechdel: Well no, it's sort of complicated. I've been doing the strip *Dykes to Watch Out For* since 1983.

Dodge: Okay. And then the characters?
Bechdel: I didn't used to have regular characters. I'd just do different themes in each episode. And then in 1987, I started working with regulars.

Dodge: So it's just sort of become a serial.
Bechdel: Yeah. It's like a soap opera.

Dodge: What used to be little stories, like the story of a—another story that I liked, and we can use this as an example of one that came before the

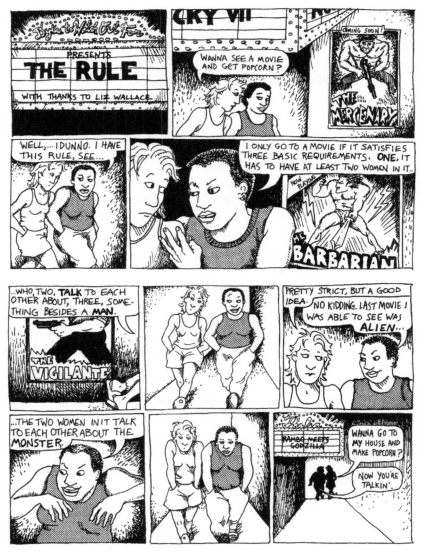

"The Rule," ca. 1985, found on page 22 of original *Dykes to Watch Out For* collection

serial—is of two women who are going to the movies, and one woman says she's got a criteria, it's several criteria. It's called "The Rule." You remember that one?

Bechdel: That's actually based on a friend of mine that really does have these criteria. She won't see a movie unless there's more than one woman in it. There's two rules . . .

Dodge: They talk to each other.
Bechdel: . . . and that that woman talks to another woman about something besides men.

Dodge: . . . besides men. And it went on to say that the movie that they had finally seen was *Alien*. And it was two women talking about the monster.
Bechdel: [laughs] Right. It's really a pretty tough rule to apply to movies, as I've tried to use it myself.

Dodge: Oh it is! But it's important.
Bechdel: Yeah, I think so.

Dodge: I remember what I was going to say: Mo and political correctness. That's a theme. She's struggling with doing the right thing. And, I'm not sure if she's the one who is vegetarian, but vegetarianism creeps up now and again.
Bechdel: Yeah.

Dodge: Tell me a little bit about that.
Bechdel: Well, I think there's a . . . I've voiced a lot of my own anxieties off onto Mo. She's kind of my scapegoat. And I don't know, but I guess I have a lot of liberal guilt, I guess I would call it, about the state of the world. As if it all falls on my shoulders to stop hate crime, corruption, and stop nuclear weapons. It's all on my shoulders in a way. I sort of foist that off onto Mo and let her take that on. She's incredibly anxious, and I think a lot of people identify with that kind of anxiety. There's something validating about seeing these anxieties that we all share validated, put out there in a cartoon.

Dodge: She's not the butt of humor though.
Bechdel: No.

Dodge: And it's a serious thing. Cartoons are not necessarily all funny. There's a real resurgence of taking cartoons seriously. So that's a serious issue.

Bechdel: Yes. Sometimes I worry that I get too serious or that I'm too didactic. That I'm trying to teach people things: that I'm trying to make people feel things. So I'm always struggling between that with, you know . . .

Dodge: With the lighter and the humor?
Bechdel: Yeah, with keeping light and funny.

Dodge: I think you do a good job of that.
Bechdel: Why, thank you.

Dodge: It's really funny.
Bechdel: It's a hard balance to strike because there are a lot of messages I want to get across.

Dodge: I'd like to talk, but not quite yet, about your actual creation of the strip and your creation of a story. But maybe briefly before that mentioning that in your first book *Dykes to Watch Out For*, there's a portrait series that's an alphabetic portrait series, "Alice," then a list, the names of all these lesbian women and their idiosyncrasies and what they do. And there's also a little alphabetical key. In each picture is a hidden picture.
Bechdel: [laughs] Not everyone gets that. That was very astute of you.

Dodge: Well, that was in the back of the book.
Bechdel: Well, yeah.

Dodge: Tell how that came to be. Was that done specifically for the book?
Bechdel: No, I actually did that, god, a really long time ago. It must have been like in '83 or '84, soon after I started doing the cartoons. Actually before I started drawing cartoons, I did a lot of stuff like that. Playing with the alphabet kinds of drawings. Edward Gorey was a great influence. Wonderful alphabet books. So that kind of came out of that influence.

Dodge: So tell me more about the early years, the early cartooning and how it came to be that you're a cartoonist and not a musician, not a laborer. Not that you're not a laborer. [laughs]
Bechdel: That's true [laughs]. I've always wanted to be a cartoonist.

Dodge: Always?
Bechdel: Pretty much, yeah. As a kid, I drew. Most kids draw a lot. But I just never stopped.

Dodge: Did you do, like, the balloons? How early were you doing that?

Bechdel: Yeah, yeah. I have a lot of my drawings and yeah, I would draw little stories. When I was a kid though, I'd draw the balloon first and then try and put the words in and they never fit, so they're all crammed, jammed in there. It took me a long time to learn to write it out first. Then you put the balloon around it. But I've always drawn. I subscribed to *MAD* magazine as a kid.

Dodge: Subscribed?

Bechdel: Yeah, I had a subscription!

Dodge: Wow, I didn't even know you could subscribe!

Bechdel: [laughs] It came in a little brown wrapper once a month. It was great. I lived for it. So that was a really big influence. A lot of children's book illustrators, like Edward Gorey. I had a lot of poetry books that he illustrated as a kid. And Charles Addams. We had a book of Charles Addams.

Dodge: Charles Addams. Also known as Chas Addams. I remember looking at his stuff.

Bechdel: Yeah, I could never understand it.

Dodge: It's the gothic.

Bechdel: As a kid, it was like that *New Yorker* style of cartoon.

Dodge: Really heavy line.

Bechdel: Yeah. Just real . . .

Dodge: It's the Addams Family, right?

Bechdel: Right. Right. But often I just couldn't understand his cartoons at all but I would read them obsessively.

Dodge: Let's look at the cartoons or the strips that you brought of *Dykes to Watch Out For*. And tell me a little bit about how you develop the story, whether that comes first, how you develop the panels. I'm curious.

Bechdel: Okay. Most people want to know if I start with a drawing or start with the words. I do begin with the words. It's sort of like writing a script or a screenplay. And after I have that all set I sketch the characters in roughly. And then it's just a process of just tracing, and I work a lot with the light table, getting everything just right. So the drawings come second, but I feel like they're real crucial to the story. It's not like they're independent. I think it's very important how they work together. I don't think I could collaborate with

someone. I'd need to write my own. A lot of cartoonists have other people do their texts, do their scripts, and I don't think I could do that.

Dodge: See I that fits in with what Waterson was saying in this speech that he gave at Ohio State which I quoted from. He referred to some of the comics strips that are continuations of ones that have been done by say a parent or the offspring of the cartoonist who continues the strip.
Bechdel: Like *Blondie*.

Dodge: And then there are the strips that are nothing but advertisements for a product. Anyway, we have here "By the Book." Is there anything you want to say here?
Bechdel: Yeah, this strip features Mo. She's the one in the striped shirt. She always wears a striped turtleneck. And this is a . . .

Dodge: Sometimes a striped tank top.
Bechdel: Right. In the summer. [laughs] This is a scene where she's getting together with her girlfriend when they were just meeting. She works in a women's bookstore.

Dodge: Or she did.
Bechdel: No, she's still there.

Dodge: She's still there? Oh I'm sorry. Madwimmin Books.
Bechdel: What did you think she did? Maybe it's time for a career change.

Dodge: No, I'm lost because I've just re-read your first two books and I'm back in history. And I read too much to remember just right now at this point in time what's happening.
Bechdel: You're doing really well at remembering stuff. I don't even remember half of these things.

Dodge: You had mentioned to me in an earlier conversation the perception that you think is out there somewhere of "cartooning is a field for people who don't write well enough to be writers or draw well enough to be artists."
Bechdel: Yeah . . . Actually, there was *Comic Book Confidential*, a movie that came out last summer and it featured a lot of underground cartoonists.

Dodge: Harvey Pekar.
Bechdel: Yeah, Harvey.

Dodge: Was Lynda Barry in there?

Bechdel: Yeah, Linda Barry was in it. Lots of people.

Dodge: Did you see Lynda Barry when she was . . .

Bechdel: At the Guthrie?

Dodge: Yeah, at the Guthrie. I was there.

Bechdel: Yeah, she was amazing. She was just like her cartoons.

Dodge: Anyway, I'm sorry. To get back to what you were saying . . .

Bechdel: Anyway, some cartoonists in that film brought that up. I think it might have been Will Eisner. And I think that's kind of true. I think of myself as sort of a dilettante in a way, which I think is not a bad thing to be. I'm not dedicated enough to writing to be a writer and I was a fine arts major in college and I really didn't like that very much. So for me, this is a real nice happy medium.

Dodge: I was going to ask you about your art background. I guessed that there was something there but I didn't know.

Bechdel: I was an arts major at a liberal arts college, which pretty much means we sat around and talked about art and didn't really produce anything. As a cartoonist, I consider myself to be pretty much self-taught.

Dodge: You've mentioned also to me previously that you feel some amount of pressures and I think you touch upon that earlier and just now with self-censorship kinds of things and not wanting to make people feel that you're commenting directly about this real person.

Bechdel: I've gotten better. I used to be that I would get totally paralyzed. I'd sit down with a blank sheet of paper in front of me, and everything that came into my head to put down, I would think, "Oh. No, that'll offend these people," or "No, this is ageist." You know, something. I've gotten over that point. I feel freer now to draw and write about stuff I care about. One thing that happens a lot is I go around, I have a slide show of my work and I tour around with it. And every time I do that I answer questions afterwards and automatically five people raise their hands. They say, "Well, I think you should have a bisexual character in this strip," "I think you should have an older woman in the strip," and "I think you should have a lesbian with children." In a way my audience is real demanding, you know?

Dodge: Critical. I would have a response for them. "Do your strip. Do your own strip."

Bechdel: [laughs] That's a good line. In a way, I value getting that kind of feedback because I do need to hear that because I want to be accountable to the community. And in a way it feels really nice that people feel like they can say that to me. I mean that doesn't seem like the sort of thing you'd say to Charles Schultz or somebody.

Dodge: It's interesting that you mention it. In looking at your characters just recently I was thinking that most of them are thirty-ish. Most of them are that age. Then I looked and went, well, there are a couple bit older women in there. It's alright.

Bechdel: Well, I'm working on it. I'm working on it.

Dodge: And it's your perspective. I would guess as you get older the characters will age.

Bechdel: That's what I want to have happen in a natural way. Sort of like what is happening in *Doonesbury*.

Dodge: I meant to mention in looking at your drawings or talking about the technical aspects of your drawings, how much I enjoy seeing some of the small details. You're good at putting cats in your panels. [laughs] There's one picture that is in my mind of, I believe it is, Mo that is doing push-ups. It might be someone else, but probably Mo. The cat is playing with her hair. She's right in mid-up.

Bechdel: For a long time I didn't have a cat. It was hard to imagine what little things cats would do, but finally, I've got one of my own.

Dodge: So now you know that they tend to put their legs up and wash their rear-ends.

Bechdel: [laughs]

Dodge: Things like that. They're fun. Those are real fun. Do you have any projects in the works outside of *Dykes to Watch Out For* and cartooning? Any dreams for the future?

Bechdel: My dream is really just to be able to do what I'm doing. I love drawing *Dykes to Watch Out For*. And I'd just really love to do it more. I do two strips a month now. I'd love to work with longer, maybe comic book story length, pieces.

Dodge: You were in *Strip AIDS USA*, speaking of comic books. That was just a short piece in there.

Bechdel: It was a benefit for AIDS. A lot of people donated cartoons about AIDS. There's a new book coming out called *Choices*, which is the same idea for pro-choice.

Dodge: Oh really! Are you going to be there?

Bechdel: Yeah, I have a piece in there. A lot of the same artists will be in there.

Dodge: You also have coming out very soon the third compilation, *New and Improved! Dykes to Watch Out For*.

Bechdel: That should be out in April of 1990. Very shortly.

Dodge: And that's Firebrand Books.

Bechdel: Yes, Firebrand Books.

Dodge: They're worth looking into. They're funny and they're neat. They're human and they're great stuff. I've appreciated having you here and it's been fun talking to you.

Bechdel: Yes, it has.

Dodge: And we'll sign off.

Alison Bechdel

ANNE RUBENSTEIN / 1995

From the *Comics Journal* #179 (August 1995). Reprinted with permission.

Alison Bechdel may be the most popular American cartoonist who you've never heard of.

Her lovingly detailed work depicts a community of women as they negotiate the challenges of daily life and respond to the horrors of global politics. To her fans, Bechdel's art distills the pleasures of *Friends*, *Melrose Place*, and *The Nation*; we recognize our world in it, with its sorrows and ironies, but at the same times we can catch up on the lives of some slightly daffy old pals. Bechdel has not been granted much space on the pages of mainstream newspapers or the shelves of comic book stores. But her strip appears in most, if not all, gay and feminist periodicals; at least one of her five books, it seems, graces the bookshelves of every lesbian in the English-speaking world.

This interview, appropriately enough, was conducted shortly after the June 1994 celebration of the Stonewall Rebellion's twenty-fifth anniversary. It suffered more than the usual number of vicissitudes on its way into print (which Bechdel tolerated with more than the usual flexibility and sense of humor). Bechdel's fifth book had just reached stores when she first spoke with the *Journal*; her sixth book will be published in October.

WHAT'S GOING ON?

Anne Rubenstein: Let's start with some questions about your work. Can you give us a synopsis of the *Dykes to Watch Out For* plot so far?

Alison Bechdel: Oh, jeez. There's a lot going on. Mo is going through a shift from sitting around passively and whining about the state of the world, to being slightly more active and whining about the state of the world. Clarice is working overtime, fighting environmental racism as the staff attorney at

a nonprofit agency. Toni, her lover, is getting a little stir-crazy at home with their baby Rafael, who just started walking. Ginger's having big-time intimacy issues and procrastinating on her dissertation. There's all kinds of stuff going on. A big event in the strip recently was when everyone went to New York for all that Stonewall 25 hoopla and the Gay Games, and I showed them marching in the International Dyke March that the Lesbian Avengers organized.

Rubenstein: Did they like it?
Bechdel: Well, they spent most of the march trying to find each other, so there was some frustration involved. But in spite of that I think they had fun. Actually, Mo didn't go to New York because she thought spending money on a big party like that was misdirected when the Christian Coalition is on the rampage against us.

Rubenstein: So what was Mo doing instead of going to the dyke march?
Bechdel: Working. She's always had this kind of low-level job at the book-store, Madwimmin Books, and now she wants more responsibility. So she's taken it upon herself to organize a reading series for local writers, which has been kind of interesting because a transsexual lesbian submitted some work. That stirred up a little controversy at the bookstore. Mo didn't want to let her read.

Rubenstein: I bet it did stir up controversy. What did they decide, or did anything get decided?
Bechdel: They had her come read. And then at the reading, some of the audi-ence was pissed at Mo for letting a "man" in women's space, and some people were glad. One woman said she was going to tell her friend Biff, a transitional female-to-male transsexual, to submit his poems. Mo didn't know what to say to that. It's always something, you know?

Rubenstein: Who are all these people, for those few *Comic Journal* readers who may never have seen the strip?
Bechdel: Those few readers! Well, Mo is the central character, and she is a thirtyish . . . oh . . . I used to describe Mo as an everydyke, but there really isn't an everydyke. So Mo really is just sort of—me. Not in an autobiographical way. The strip isn't about my life. But Mo sort of looks like me, we have similar backgrounds . . . you know, it's hard to give good little sound-bite descriptions of my characters. I always end up oversimplifying everyone and sounding like a book jacket blurb. Maybe we could talk about something else first.

SOMETHING ELSE

Rubenstein: Well, in that case, what's the story of your life? Were you always interested in cartooning?

Bechdel: Yes. Yes! I've always drawn cartoons, and I've always looked at them. I mean, even before I could read the captions, I thumbed through the *New Yorker*. Maybe it's hard for me to give a good general description of my comic strip because cartooning is such an intrinsic, preverbal part of my nature.

Rubenstein: Was your family artistically inclined?

Bechdel: Yes they were. My mother was an actress until she gave it up to get married and have kids. Both my parents taught high school English, but did other stuff on the side. My Mom did a lot of summer stock—acting and doing costumes. And my father was president of the local historical society. He was a big antiques collector and sort of freelance interior designer. Both of my parents were pretty good at drawing and painting, but they didn't pursue it at all. My mother's father and brother also both drew but I only found that out recently. My family was really nuts in some ways, but there were great about encouraging my drawing. My dad would go to the local paper mill and buy me whole reams of typing paper to draw on.

Rubenstein: So they weren't horrified to have a junior artist on their hands?

Bechdel: No, I never had to deal with that. No one ever tried to steer me into being an accountant or a dental hygienist.

Rubenstein: Did you read comic books as a kid?

Bechdel: Not a lot. I'd pick up a *Richie Rich* or a *Little Lulu* every now and then, but I was never obsessed with comic books. Except *MAD* magazine. I loved *MAD*. I actually had a subscription, and I lived for the day it would come in the mail. I would devour it immediately.

Rubenstein: You did have good parents.

Bechdel: Yeah, my mom shuddered a little bit, but she always let me renew the subscription. Other big influences on me as a kid were Norman Rockwell and certain children's book illustrators. We had some books of children's poetry that Edward Gorey illustrated, which I pored over endlessly. I didn't discover his adult work until I was in college, and then I became a total fanatic. But even when I was little there was a quality in his drawings that really fascinated me.

Rubenstein: You can see it in the way that you deal with line.

Bechdel: Huh. Thanks. I also loved Hilary Knight's work, the guy who did the *Eloise* books. And Dr. Seuss. And Richard Scary's picture books. I loved all those complicated scenes—

Rubenstein: With all the details.

Bechdel: All the details, and all his little labels for everything. I loved that! I've always loved the way that words and drawings go together. In a lot of my drawings from when I was five or six and first learning to read and write, I would put these little random letter forms around my drawing, because I loved the way that it looked.

Rubenstein: So you were a cartoonist before you could even write. Did you always know that this was what you wanted to be?

Bechdel: As a kid I did. I recently found a questionnaire I filled out when I was eleven, about what you imagined you'd be doing in twenty years. And I said I'd be a cartoonist. But then as I got older it didn't seem feasible. By the time I was in college I thought I would go into graphic design, or maybe book design. Sometimes I think that if I hadn't been a lesbian I would have gone into advertising. Being a dyke was really my salvation.

Rubenstein: Wait. You couldn't go into advertising because of being a lesbian? Explain that to our readers, please.

Bechdel: I guess that was sort of a leap. [laughs] For me, when I realized that I was a lesbian, my whole worldview shifted dramatically. I was used to seeing things as a white, American, Catholic middle-class girl. I had never thought about the world, about politics, about how power structures work. I just thought that people got what they deserved. That was how I saw the world until I suddenly found myself outside of it all. Once you're outside, there's like a Scenic Overlook, you know? You're able to see the big picture in a way you can't if you're part of the system. So I was able to see things like sexism and racism and capitalism as a systemic problem in a way I hadn't before. So now I see the advertising industry for the morally bankrupt, soul-murdering, consumption-perpetuating con game it is. But if I'd never gotten kicked outside, I might very well have pursued a career in it just for the love of combining words and images and being clever, without ever thinking "to what end am I doing this?" That's why being a dyke was my salvation.

Rubenstein: You knew that you wanted to be a book designer or have some kind of relatively arty career. But you didn't go to art school.

Bechdel: No. I was always a good student, and everyone told me I wouldn't get a good academic background at an art school. And that was important to me, so I went to a liberal arts college.

Rubenstein: Do you miss it now, not having had an intensive art school training?

Bechdel: Yeah, I miss having the technical training. I went to two different colleges. The first was Simon's Rock, which was a very small school where I got a lot of attention from my art professors and produced some good work. Then I transferred to Oberlin, where all we did was talk about art. We got very good at talking about art, but when I left there I had nothing, no portfolio. So, yeah, I wish that I had gotten more practical training. But I got other stuff instead.

Rubenstein: What else did you get?

Bechdel: Well, I guess my biggest accomplishment was coming out. That's the main thing I'm grateful to Oberlin for. And I also picked up a dilettantish, quasi-intellectual, pseudo-academic kind of avant-garde attitude that proved to be socially useful. I learned a little bit of everything on a Sunday crossword puzzle level.

Rubenstein: So you came out in college? And your family is Catholic? How'd they deal with that?

Bechdel: Well, actually my father was a Protestant, but my mother is Catholic. My brothers and I were raised Catholic, because my mother cared and my father didn't. Actually, that's kind of how they were about my coming out too. My dad took this sort of laissez-faire attitude, and my mom was really quite upset. I was nineteen, and I hadn't even had sex with anyone when I told them. I just knew, and I was so excited about it that I wanted them to know this great thing. It's actually a much more complicated story than that, kind of tortuous and sordid in that way families are, and I'm going to write a long cartoon novella about it one day. So I can't reveal too much of it now.

Rubenstein: I wanted to ask about your family's politics. Did your own politics come out of theirs? And also, so much of your work deals with the ways that people create alternative families for themselves, substituting friends for kin. I wondered how much of that came out of your own experience or your friends' experiences?

Panel from "Coming Out Story" for Oberlin College LGBT Community History Project

Bechdel: My parents were culturally liberal, and politically fairly conservative. But there was no analysis in our house, there was no discussion of world events, or even local events. No one read the paper or watched the news. My parents would get the Sunday *Times* and read the arts and leisure section then throw the rest out. And so, when I started coming home and talking about

radical politics, I think it was sort of an embarrassment. We just didn't talk about those things. I do remember one political thing my mother did, though, which was to go to Washington and march against *Roe v. Wade* in 1973 or whenever that was. She didn't really talk about it to us, she just went. It was interesting to me to see her take a stand like that, to realize she cared enough about anything to do that. My mother has this very clear sense of right and wrong which I inherited—though we're certainly on different sides of the abortion issue—but it was just never anything that we talked about. It was like there was something embarrassing about belief in anything.

Rubenstein: So for you, coming out and becoming a radical in other ways was a real push away from where you started out, from what you though you would be.

Bechdel: Oh yeah, very much. But you know, the truth is, in some ways I haven't shifted all that much. I mean, I go to marches and stuff, and I'm a lot more involved than the rest of my family, but I'm far from being an activist or an organizer.

EDGING UP ON GARFIELD

Rubenstein: So you got this liberal arts education and you got out of college and then what happened?

Bechdel: Well, I was rejected by all the graduate programs I applied to—today I think that was just as well, but at the time I was kind of bummed. So since I had nowhere else to go, I moved to New York City with my girlfriend. I did a lot of menial publishing industry kind of jobs. Proofreading, word processing and stuff. And I started volunteering at a feminist newspaper called *WomaNews*, where I did paste-up and production and wrote an occasional review. And I also got very involved with martial arts. I was studying karate four times a week for several years. So I was doing all this stuff and I was never home and it was a really exhilarating, big city kind of life.

Dykes to Watch Out For started somewhere during that period in the early eighties, in the margin of a letter to a friend. I drew this whacked-out lesbian holding a coffee pot, and called it "Marianne, dissatisfied with the breakfast brew: Dykes to Watch Out For, plate number 27." Even though it was the first one I ever drew. It was just this silly, literally marginal thing. But something about it really held my interest, and I started doing a series of drawings of these whacked-out lesbians. A friend who I worked with at *WomaNews* persuaded me to submit some of them to the collective for publication. I hadn't

Marianne, the first dyke to watch out for, 1982

"Marianne, dissatisfied with the morning brew: Dykes to Watch Out For, plate no. 27," original *Dykes to Watch Out For* panel, 1982

joined the collective yet. And they ran two cartoons in the 1983 Lesbian Pride issues. We handed out copies at the Pride march that year, and I was so elated that my work was getting passed around, and getting read. People did read it, and responded to it immediately. It was really thrilling to actually see people react to my cartoons, to laugh. I was so happy. I knew it was something I wanted.

Rubenstein: And you've been a cartoonist ever since?
Bechdel: Yes!

Rubenstein: In 1983, how many good, or even half-decent, lesbian cartoonists were there? You were filling an enormous need.
Bechdel: Well, of course I just thought it was because I was brilliant. [laughs]

Rubenstein: Journalist extracts foot from mouth and apologizes. [laughs]
Bechdel: No, no, it's totally true, I was in the right place at the right time.

Dykes to Watch Out For, *plate No 19*

Early *Dykes to Watch Out For*, 1984

Twyla is appalled to learn that Irene is a morning person.

Rubenstein: Of course, in 1983, there were some lesbian cartoonists who weren't funny or couldn't draw. But only a few who were good. And so then what happened?

Bechdel: I did one-panel cartoons for *WomaNews* for maybe another year, then I expanded to doing a whole strip. I'd been hesitant to do a strip because it meant you had to draw the same characters more than once. When I finally tried it, I found that you really didn't have to make them exactly the same from panel to panel, you could just sort of fake it. And I really liked doing a strip much better. I ran out of fuel very quickly with the one-panel format. I don't know how any anyone can do that for any length of time. It's so much more difficult to say something in one panel. So I started doing strips, and I thought maybe some other people would be interested in them, so I wrote letters to a couple of gay and lesbian newspapers and started building up, self-syndicating. I've really just sort of made it up as I've gone along. I started with two or three papers. Gradually, over the years it's grown to about four dozen. That's partly a reflection of the growth of gay and lesbian press. I mean, there just weren't that many publications in 1983. Then as papers started popping up in new cities, I had a wider potential audience.

Rubenstein: How quickly did you move to continuing characters?

Bechdel: I had been doing the strip for four years before I started drawing Mo and the rest of the gang in 1987.

Rubenstein: Your first book from Firebrand doesn't have any of those characters in it. Just panels and alphabets—very Gorey-esque, actually. When did you do that work?

Bechdel: That was a compilation of work I did from 1983–1986, and it came out in the fall of 1986.

Rubenstein: How did the book come about?

Bechdel: One of my first fan letters was from Nancy Bereano, who was the editor at a small press. I was just a kid, I didn't know you were supposed to answer things like that. So I ignored it. But then, a year later, she wrote me again and she said she was starting her own publishing company called Firebrand Books, and she was going to be in New York for a visit, and could we have a meeting about doing a book of my cartoons? So I met with her, and she was very encouraging. I didn't have a vast audience at the time. She really had a lot of faith in me, to seek me out like that and publish me.

Rubenstein: Her risk paid off very well for Firebrand though. I interviewed Nancy Bereano a few years ago and she said that your work provides enough profit that her press can afford to put out a few more good but unprofitable books every year. All five of your books are still in print, you put out a calendar too, and they're all on the shelves of every women's bookstore, every gay and lesbian bookstore, and some regular old bookstores too.

Bechdel: Well, it's been incredible. I remember when I got a second royalty check from my first book. I was totally shocked. I had thought, oh, I'll get this first check for $800, and that's great, but I never expected that I would get anything more. My stuff seems to keep selling.

Rubenstein: Do you know how many copies of that first book are still in print?

Bechdel: The first one? Jeez, I don't know. But I think counting all the books and all the calendars, I've sold something over a hundred thousand copies.

Rubenstein: Edging up on *Garfield*.

Bechdel: Hardly. [laughs]

Rubenstein: So your strip appears in four dozen newspapers, you've got five books in print . . . is there another one coming out soon?

Bechdel: There's one scheduled for the fall of '95.

Rubenstein: And you have the calendars. Besides all that, what else are you working on?

Bechdel: I'm always doing some little project. A fundraiser or poster for some gay or lesbian thing. I just did a poster for the Gay and Lesbian Anti-Violence Project in New York. I've done a couple of pieces for *Ms*. Book covers. Little odds and ends like that.

Rubenstein: Who did you do a book cover for?

Bechdel: A book called *The Lesbian Post-Modern* from Columbia University Press—an academic book.

Rubenstein: That sounds unusually snappy for an academic book.

Bechdel: Yeah. I was kind of disappointed with the way the final cover looked, but it just won some design award for scholarly books. I suspect the competition in that category is not particularly fierce. Anyhow, I'm always doing a project or two like that. And I do a lot of speaking gigs at colleges and other places.

Rubenstein: What do you speak about?

Bechdel: Myself. [laughs] I have a slide show in which I talk about my own work, as an artist and a lesbian, and then I also talk about the representations of women in popular culture, with lots of cartoon examples. I talk about how as a child I never drew women or girls. I always drew men. I go into various theories of why I did that, about how females are presented in cartoons as other.

Rubenstein: Yes, "normal" is male and "different" is female in comics.

Bechdel: Right. And changing that, not just in the comics, but in the world is my mission in life. As a very, very young girl, I could see it so clearly. Men get represented as "universal" and women get represented as a sexualized subset, an aberration. I didn't want that. I wanted to be a regular human, I wanted to be a whole person, I wanted to be a subject in the world, not an object.

Rubenstein: There's some artist, I forgot her name, who papered a room with the front pages of newspapers from around the world, from the same day, and removed all the words. So all you saw was men, men in suits, always standing. The world was male. I wouldn't have believed it if she hadn't shown it.

Bechdel: Cartoons are such a good place to explore this stuff, because it's all so transparent. One of many ways that Garfield sucks, for example, is the way it represents women. All the "regular" characters are male, but every once in a while when the gag is something to do with sex, they import a female character. And Garfield is drawn like a regular cat, basically, but the female cat is drawn with these really bizarre human lips, so she looks like a completely different species than Garfield. I just think it illustrates so nicely the treatment of women as "other." There's all kinds of ways cartoons do this. Drawing women with exaggerated, fertility-goddess breasts and hips. Never giving women the punch-line. Or just never including women at all.

Rubenstein: I once heard Art Spiegelman's response to a student who had asked him why some cartoonists Spiegelman admired—Kurtzman or someone—gave all his female characters big hips and big tits and big lips. Spiegelman said something like, well, that was so that you knew that the girls were girls. You had to telegraph. But it's really only female gender that gets exaggerated.
Bechdel: Exactly! And that was brought home to me when I discovered the work of gay male cartoonists, with those bulging crotches and tiny little butts and huge shoulders. They exaggerated maleness. And that, all of a sudden, helped me to really see Blondie and Miss Buxley for what they were. Because like everyone else, I'd gotten desensitized to it. I was so used to seeing women represented as, you know, those silhouettes on truck mudflaps, that it didn't even strike me as weird.

Rubenstein: In real life, half the time you can't tell the sex of someone who's a block away. But Spiegelman only saw it as a technical problem. He didn't want to touch the ideological implications, if he saw them.
Bechdel: I'm sure he didn't see them. That's the whole problem. I really think most men are incapable of understanding this fully. There's too much ontological privilege at stake.

Rubenstein: How often do you take the slide show around?
Bechdel: I used to do it maybe ten or fifteen times a year, but I'm really tapering off because I don't like to travel very much.

Rubenstein: You're incredibly prolific for someone who has spent that much time on the road.
Bechdel: Do you think? I always feel like I never get nearly enough done.

DIFFERENT PARTS OF ME

Rubenstein: What do you do for fun? Do you have time for fun?

Bechdel: Not very much. In two weeks, I'm going on the first vacation I've had in seven years. I'm excited about that, but in a way, you know, I have such a fun life. I don't really need a vacation. I do work really, really hard, and lately I'm feeling on the verge of burnout but for the most part my work is very energizing and sustaining.

Rubenstein: You live in Vermont, right? Did you grow up there?

Bechdel: No, I grew up in Pennsylvania, in a rural place that's a lot like where I am now. I spent my twenties in New York and Minneapolis, and I really miss the stimulation of a large city, but I couldn't take the stress anymore. I'm right in the Green Mountains now, and except for being essentially monocultural, it's a nice place to live.

Rubenstein: Is there much of a community there for you?

Bechdel: There is. It's a little harder to get to, and there's not quite as much going on, but what there is, is very enthusiastic.

Rubenstein: Okay, I want to circle around to your work again. Where did the story start?

Bechdel: I knew that I needed a central character to work around, and that for her to ring true, I'd better be writing from personal experience. So I came up with Mo, who was this young white middle-class dyke, vaguely based on me. I tried to disguise her by giving her longer hair than I have, and glasses, but the resemblance is still pretty apparent. Mo is the extreme embodiment of the lesbian-feminist social conscience.

Rubenstein: I know a lot of people who identify with Mo: intensely worried by how much more they have than many of the people they see, and feeling responsible for all of it.

Bechdel: Mo represents for me the struggle of how to live responsibly in a culture whose priorities are as horrifically skewed as ours. She's angry at the people who are living these conscience-free lives, going to the mall and working for corporations. And yet she is wistful; she wants to have a big TV, and she wants to have a new car. And then of course, she's appalled that she has these desires. She has a real conflict with the culture, which I guess I share.

Although in a less extreme way. I'm probably as judgmental as she is, I'm just better at hiding it.

Rubenstein: Well, presumably you don't drive everyone around you crazy, the way Mo does. That's where a lot of the humor in the strip comes from. For instance, she had this girlfriend Harriet for a while, and . . . What happened to Harriet?

Bechdel: They broke up a couple of years ago, mainly because Mo was such a pain in the ass. Finally what pushed Harriet over the edge was when she came home with a VCR so she could tape *All My Children* while she was at work, and Mo started lecturing her on the addictive spiral of consumer spending.

Rubenstein: So Mo is the center of this circle of friends . . .

Bechdel: Yeah. All the other characters are based on different parts of me. Kind of like Sybil. Lois is my latent bad girl side. Clarice is my workaholic, ambitious side. Toni is my romantic, domestic side. Ginger is my hyper-rational side. Sparrow is my spiritual side. All of these characters play off of Mo in some kind of oppositional way.

Rubenstein: And there are no men at all in *Dykes to Watch Out For*. We were talking before about how annoyingly male-identified—

Bechdel: Masculinist?

Rubenstein: How masculinist some women cartoonists are—the way that they seem to be explaining their lives to really clueless men. All that gee-I-was-so-drunk-last-night-how's-my-manicure. Although there are some presumably straight women who do everything you were talking about, including making a lot of art out of their love lives, and yet seem to be coming at it from their own angle.

Bechdel: Well, I think it's sad but true that a lot of women cartoonists, from Cathy Guisewite to even some of the most twisted underground artists, perpetuate the "women as other" problem. They're just so focused on men, you know? Like, I'm just flipping through a copy of *Real Girl* and looking at a piece by Diane Noomin . . .

Rubenstein: Ah-ha!

Bechdel: [Laughs] But I don't want to pick on her. She does some good stuff, it's just that Didi Glitz character that bugs me. Now, someone whose work I

really love is Dori Seda. She kind of did the same thing that Diane Noomin does, but somehow it's different.

Rubenstein: Everything in her work revolves around her. When men draw themselves as the center of every story, it's tiresome, but when women do that, it's still surprising.

Bechdel: That's it. When straight men write about women, the focus of the piece is the man. But a lot of the times when straight women write about men, the focus is still the man. It might be about what a jerk he is, but it's still about him. It's really hard not to write about men. I'm a lesbian writing a strip that has no male characters in it—and people somehow manage to construe even that as being a statement about men. My strip is not "not about men." It's simply "about women."

What I want is for men to read my work, and make the same leap of identity that we have to make when we read one of the 99 percent of comic strips that star straight white men, boys, or animals. If I can identify with *Calvin and Hobbes*, why can't some guy read my strip and identify with Mo? That's my subversive plot to undermine the universal male subject.

Rubenstein: Your characters remind me in some ways of the characters in Peter Bagge's *Hate*. In terms of socioeconomic status and general outlook on life, both your characters are slacker-types. They're not working up to the level they've been educated to—and they sit around complaining and feeling marginalized by mainstream culture. Yet the characters in *Hate* are miserable, and the characters of *Dykes* seem happy.

Bechdel: I've only read a little bit of *Hate*, and I'm situated somewhere in the grey area between baby boomers and Generation X-ers. But I know what you mean. That nihilistic, "fuck the world" kind of thing. I think the difference with my character is that they're each involved in some way in changing things. They're actively forging an alternative to the brain-dead stupor most people this country live in, instead of just criticizing it or sitting around whacking off and succumbing to it. It's not as hip, but that's the difference between my characters and your garden-variety slackers.

PROCESS

Rubenstein: Have you thought about working in other media? Film, theater . . .
Bechdel: No. Cartooning is pretty much it for me. Every once in a while someone wants to do a play based on my characters, but I can never get excited about

the idea. They're cartoons, you know? I don't want to see them in three dimensions. And I wouldn't trust anyone else to do the writing, and I don't have the time or skills to write a play. I would like to do some animation at some point, though. It would be so cool to see these women move and talk. But basically, I'm really happy just doing my strip. I love working in black and white, I love line, I love combining words and pictures.

Rubenstein: What is your working process? Do you still use typewriter paper?
Bechdel: No, I use a big slick sketchpad now that I've gone pro. Should I tell you how I create a strip? First, I procrastinate until the last possible minute. Then I go to the huge stack of magazines and newspapers I get every month and skim through them, making notes about what's going on in the world, and in the community, what the latest issue is, what people are wearing . . . I just feed all this stuff into the hopper. Then I get out my big chart. I have all my episodes listed on one axis, and all my characters on the other so I can track what's happening to whom and whose story needs attention.

Rubenstein: That must be quite a chart by now.
Bechdel: It's what soap opera writers use. Anyway, then I try to mesh the lives of the characters with what's going on in the world at large. The plot kind of creates itself from the tension between these two things. Like, Mo is on a date but she can't relax and enjoy herself because she's so worried about the possibility of a Republican, religious right-backed White House in '96.

My standards are always getting higher, so the whole process gets progressively more challenging and time consuming. The writing is very labor-intensive. I like to have a very structurally sound script before I start drawing.

The drawing is easier for me. When I finally get to do it, it's a pleasure. I start with a real rough sketch, and then I go over it again with tracing paper to refine it. I use myself as a model for lots of the poses, rigging up mirrors and stuff. I'll use other people if they're around, and I just got a Polaroid which I'm using more and more. I used to think that was cheating, but it actually introduces more of a challenge. Then I go over the sketch again to get it down really good, and then I trace over that with a light box onto Bristol board, and then ink it. By the time I finally get to inking, I've drawn the fucking thing five or six times. It's like I've done rehearsal after rehearsal and now I get to just do it. Inking the outlines is the greatest pleasure in my life.

Rubenstein: When you say that you're looking at magazines for ideas, do you mean *Times* and *Newsweek*?

Bechdel: No, it's mostly—I get a foot-high stack of queer papers every month. And 'zines. And I get *The Nation* and *Ms.* And miscellaneous newsletters and magazines. *On Our Backs*—rather, *Off Our Backs*. Well, actually, I read them both. And the daily paper, of course. It all goes into the hopper.

Rubenstein: How much lead time do you have? One of the interesting things about the Gulf War series was that, as soon as the war started up, it seemed like you were right there with it. Are you really sending them in only a week or two in advance, or is it usually longer?

Bechdel: I'm never ahead of schedule. It takes a deadline for me to turn anything out, so I'm as timely as I can be considering I do a strip every two weeks. But I have a real struggle getting papers to stay up to date with my storyline. It's very frustrating. A big part of the value of my work, I think, is that it's about what's happening right now. But a lot of what I wrote about the Stonewall anniversary in June won't come out in the papers until August or September. That diminishes the impact so much. The thing is, the papers that carry me all publish at different intervals. Some are biweekly, some are twice a month, some are monthly. A few are weekly. It's just an erratic schedule. And only some papers run all my strips. A lot only use one a month.

Rubenstein: I remember the late *Gay Community News* from Boston, which always had no-space problems. They would go for months with no cartoons, and then they would have a slow week and catch up on four at a time.

Bechdel: It's one of the banes of my existence.

Rubenstein: So much of your work is in the details. Do you have any control over what size your cartoons are reproduced? I remember *Outweek* used to make them tiny, and all the best bits would be lost. Is that frustrating for you?

Bechdel: I work small, for a cartoonist, with small lettering and lots of details. Usually what you see in the papers is half the size I draw it. It's a little hard to read, but there's not much I can do about it. If I drew bigger panels, I wouldn't be able to tell as much story. It would be great if papers would run it bigger, but it already takes up a lot of space. Fortunately, all my strips eventually get published as a collection in a book, and they're reproduced there at 75 percent instead of 50 percent.

Rubenstein: You could see it as a way of forcing people to buy the books even if their local paper carried the strip. So . . . what kind of nib do you use?

Bechdel: I use a Hunt number 100. I use a fair amount of pressure, and like the lines it makes best when it's really broken in. Then when I get it just right, it loses all its spring and I have to start on a new one. For a long time I used mechanical pens, because I thought they gave me more control, but I was so wrong. I switched three years ago.

SOMETHING USEFUL

Rubenstein: And what else did your characters do at the Stonewall celebrations besides the dyke march?
Bechdel: Well, Sparrow and her girlfriend got all dressed up in reverse butch/femme drag and went to the Asian Lesbian Network event. Lois tried to grope at least one athlete from every sport in the Games. She came home with a big collection of t-shirts and a nice pair of boots she got from an Australian shotputter. Ginger ran into this woman she had had a fling with at the Black Gay and Lesbian Leadership Forum Conference last winter, but this time she was with her lover, the wrestler. Did you go to the march?

Rubenstein: Yeah!
Bechdel: It was one of the harder strips I've ever done. Getting all the background characters down was a real challenge. My realist tendencies reached a new height with this strip, because I included lots of actual women who were at the march, and showed them interacting with my characters.

Rubenstein: It was an event that was worth capturing. It was so cool to be surrounded by thirty thousand women in the middle of New York.
Bechdel: Did you go to the one in DC last year? The one in DC was much more moving to me. I don't know why. I guess I'm just jaded.

Rubenstein: Do you think of your work as political art?
Bechdel: Well, there's always this political thing attached to just being a lesbian, right? That being out is a political act. So in that sense, maybe. And I do use the strip as a vehicle for political commentary. I guess I kind of balk at the label a bit because the truth is all art is political. *Dennis the Menace* is political. It's just a question of which side you're on. Also, "political art" has a connotation for me of really heavy-handed propaganda that's thinly disguised with mediocre-to-bad technique. And I guess that's my worst fear about my work. I try really hard to balance my message with my medium, but I succeed to varying degrees.

Rubenstein: Do you think that you've changed people's opinions about things?

Bechdel: No, I don't think so. But I do think that, just by reflecting the experience of my subculture, I do something useful. I think of what I do as entertainment, but a nourishing kind of entertainment. I think my audience really needs the kind of reflection of their lives that my comic strip provides. I do too. I think I would go on creating the strip even if no one else read it, just because I need to see it.

Rubenstein: Billy Bragg, the leftwing folk singer, was asked if he was preaching to the converted, and he said no, he was cheering on the troops.

Bechdel: Yeah!

Rubenstein: You recently got a call from Universal Press Syndicate about developing a gay strip for the mainstream dailies. Is that something you're interested in?

Bechdel: That happened over a year ago, but I still haven't quite gotten over the shock. I guess what happened is, Lee Salem saw an interview with me that ran in the *Boston Globe* and had one of the associate editors call me because they felt the market was ready for a gay strip. It was in the wake of all that brouhaha over the queer kid in *For Better or For Worse*, and they'd gotten a lot of supportive letters. The woman I talked to said they were thinking of a strip that had both men and women in it, and that was "less political" than *Dykes to Watch Out For*.

I thought about it for a couple of weeks. I was a little starstruck, because I know they just don't go inviting submissions like that. But eventually I came to my senses and told them I didn't want to pursue it. I'm really happy doing what I'm doing. And I have less than no interest in speaking to the mainstream. I mean, if my works ever got banal enough to make it into a mainstream newspaper, I hope someone would just put me out of misery.

Sing Lesbian Cat, Fly Lesbian Seagull: Interview with Alison Bechdel

WESLEY JOOST / 2000

From *The Guardsman*, May 15, 2000.

If you've been a regular reader of *Dykes to Watch Out For* you're already hooked on the intricate weavings in the stormy lives of Bechdel's dynamic characters: "Mo, Our Hapless Heroine—Jezanna, The Type-A Boss of Madwimmin Books—Sparrow, Battered Women's Shelter Worker, Inner-Growth Addict—Ginger, Doctoral Candidate and Procrastinatrix Extraordinaire—Clarice, Mo's first ex-lover, Workaholic Attorney for the Environmental Justice Fund . . ." not to mention Lois, Thea, Toni, Rafael, June, Malika, Ellen, and Harriet.

All of these people comprise Bechdel's politically overactive, vegan alternative, Queer cultural, Mo-Centric Universe. To get the lowdown on what's happening with these off-Melrose Place women you should look for the pink triangle on an independent bookstore near you (not Bunns & Noodles) and pick up one or all of the many *Dykes to Watch Out For* book collections. Her latest episodes can be found in *Bay Times* twice a month so don't miss it, because *Soap Opera Digest* will not fill you in.

Guardsman (GM): Could you give us a summary of what's happening in your strip in the past year?

Alison Bechdel (AB): The most interesting thing to me is the bad character I've introduced—Sydney, the evil women's studies professor. I was getting tired of writing about such paragons of virtue all the time. Sydney's really insufferable, but I love her because she brings a whole new level to the strip. I was getting the feeling that people might be taking my cartoons too seriously. When I got a one-paragraph review in the *Lambda Book Report* which manages to use the phrase "politically correct" three times, I knew I had to

do something. So I'm kind of using Sydney and her over-it-all postmodern attitude to reframe the strip, to take a little wider and more ironic perspective on things. And Mo, my main character, has this combination feud/flirtation going with her, which is kind of fun.

GM: Do you have to chart the plot or do you improvise it?
AB: I have a meticulous, complicated chart that's constantly under construction. I think it's actually similar to the system real soap opera writers use. It's a big grid with the characters running down the left hand column and the episode numbers running across the top. Now I have it on my computer, and I can keep track of what's already happened in one color, and what I think is going to happen in another color.

GM: In your strip some characters adopted a baby. Is that a major trend among lesbians in real life?
AB: Well, lesbians having babies is a major trend. And because the birth mother is the only one legally recognized parent, the nonbiological parent has to go through an official adoption process in order to have a legal relationship to the kid. So lots of women are pursuing these second-parent adoptions. Until recently they were pretty routinely denied, but now more and more of them are successful. I'm not particularly into the marriage and kids scene personally, but I think the legal issues they bring up are really important. So I use the lesbian family in my strip to discuss that stuff. Clarice, the nonbiological mom in the strip, is torn between wanting legal status in regard to her son, and hating to involve the state in her life in this intimate way.

GM: Are you making a living from your strip?
AB: Yeah, fancy that. For eight years now. But I'm a pretty big scammer. I sell t-shirts with my characters on them and I do a calendar every year and I schlep around the country doing a slideshow and my books get published regularly. It was after I had a couple of books published that the royalties added up to enough to supplement my syndication income without a second job. Altogether, my six books and my calendars have sold about 150,000 copies. That might sound impressive, but it's been over a period of ten years. I have an incredibly loyal bunch of fans, and it's thanks to them that I've been able to keep *doing this*.

GM: Do you think there's any chance you might be nationally syndicated some day?

AB: Not in my lifetime. Actually, I got a call from Universal Press Syndicate a couple of years ago. They were thinking of developing a gay and lesbian strip for the daily papers and wanted to see if I wanted to submit some ideas. That was my chance at mainstream but I didn't take them up on it, because there just seems to be too many limitations in doing something for that broad of an audience.

GM: But there's so many gays in mainstream media now.
AB: Oh, god. That whole TV scene just bugs me so much. I don't want to be yet another commodity on network TV. I like being a pervert in the twilight.

GM: Your strips are always involving current political events; are you kind of the lesbian *Doonesbury*?
AB: I certainly admire how Garry Trudeau does that—he's brilliant at it. I'm trying to do a little bit of his shtick, interweaving my characters' personal lives with things that are going on in the larger world.

GM: To what extent are you ambiguous about the political correctness of some of your characters? It seems like they're almost parodying themselves with their intensity.
AB: That's such a complicated question. The whole phrase "politically correct" sends me into paroxysms. It's been twisted around so many times I don't even know what it means. It used to be a joke and I think it was a useful joke, you know pointing out just what you said, how . . . oh, I don't know, my characters are politically correct. What can I say. It's hard for me to think clearly about this because I think the principles behind "political correctness" are very worthy. To be kind to people—that's the basic concept. You know? Get over it.

GM: There was an episode in *Dykes to Watch Out For* where it was awkward to have a male-to-female transsexual at an "All Women" poetry reading. Is it really that awkward in real life? Do you see transsexuals as men in sheep's clothing?
AB: You know, I used to. But this whole transgender movement has really shaken up some of my previous conceptions. I'm not exactly the most informed person on the topic—I've gotten more of what I know from reading. One of the key concepts that you have to let go of in order to understand transgender is that orientation and gender are not connected in any way. You can be a biological female who thinks herself as a male, and is attracted to men, you know? Any combo is possible. I find queer culture increasingly difficult to keep up with. It's always changing. Just when I get a handle on things, then

something more outrageous than you could ever dream of starts becoming an everyday occurrence. The female-to-male transsexual thing is really fascinating, and I need to discuss it in the strip. I have so many issues to keep track of.

GM: You must be pretty sheltered in Vermont.
AB: I am pretty sheltered. I make it out to the big city once or twice a year and then I madly try to absorb as much culture as I can. For the most part I live in the woods and get my culture secondhand from reading about it or talking to friends who live in the city.

GM: Is there anything you'd like to tell people who are just being introduced to your work through this article?
AB: The secret subversive goal of my work is to show that women, not just lesbians, are regular human beings. I want to create women who get to be "universal" the way, historically, men have gotten to be universal. Like Dagwood is just a regular person, but Blondie is a female person. Women are rarely represented as generic human beings. Almost every film, commercial, TV show, comic strip you look at, presumes a male audience and focuses on male characters. (Or if it's a deodorized panty liner ad or anything on the Lifetime channel, it presumes a female audience desperate to attract men's attention, which is basically the same thing.) My goal is to create women characters who are regular, generic people. I want men to read my strip and identify with Mo the same way women and people of color make a leap of identification to watch a Woody Allen movie or read *Garfield*, you know?

GM: Maybe you should make them lesbian cats [laughter]. Is that why you haven't had any male characters in the past—you just recently added one.
AB: Yeah, that's exactly why. But I feel like it's not such a big deal anymore. I introduced this guy Carlos, who's a friend of Clarice and Toni's. He's been hanging out with Raffi, their three- year-old son. I haven't done much character development with him yet, though.

GM: Do you feel attached to your characters like they're good friends?
AB: I don't talk to my characters or dream about them. It might sound kind of corny but it's kind of like they exist in this parallel world and I just kind of tune into them and find out what's going on each week. I don't really feel proprietary about them—they just exist. My job is just to listen to them as carefully as I can.

An Interview with Alison Bechdel

JOHN ZUARINO / 2007

From *Bookslut*, March 2007. Reprinted with permission.

Having exploded onto both the books and comics scenes with her graphic memoir *Fun Home* in the summer of 2006, Alison Bechdel has become a household name for comics aficionados as well as the uninitiated. However, she has been an active cartoonist since the early eighties. Her long-running strip *Dykes to Watch Out For* recently celebrated its five-hundredth episode, and the gals (plus one straight man in a man-skirt) are still going strong, despite the fumbles and follies of the Bush administration.

Fun Home has garnered vast media attention, both for the writer as well as the graphic medium. *Time* called it "book of the year," and a library in Missouri even tried to have it banned from its shelves over incidents of frontal male nudity and explicit sexuality. Librarians claim that, because the book is illustrated, it will attract children.

On the morning in which this interview took place, Bechdel spoke at a forum on gay identity in comics with Ariel Schrage, Abby Denson, and Jose Villarubia at the New York Comic Con. What started out as a discussion of queer identification in comics turned into a free-for-all: audience members suggested that the panelists incorporate gay themes into children's books. The forum ended with Villarubia reprimanding a Latino comics fan for strongly identifying with Speedy Gonzales, an offensive Mexican stereotype that has been blacklisted from several television stations.

After dodging hundreds of sexual angst-ridden storm troopers and fanboys in Jedi uniforms, I sat down with Alison in a well-hidden niche near the event space at the Jacob Javits Center in New York.

John Zuarino: How is the writing experience different between fiction and memoir, or rather how does it differ when writing a *Dykes to Watch Out For* strip versus seven years on *Fun Home*?

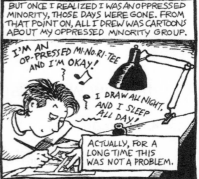

"Oppressed Minority Cartoonist" in *Juicy Mother* edited by Jennifer Camper; originally for *The Stranger*

Alison Bechdel: The main difference is that with my comic, it's pretty much a known quantity. I know what I want to say before I say it, and then I just have to figure out how to get it all in under ten panels. But with *Fun Home* it was the opposite. It was like discovering what I wanted to say as I went along. It was a very elusive process. It was actually seven years altogether that I worked on it, and it was probably not until halfway through that time that I really had a sense of the shape and structure of the book. I was just kind of muddling around for a long time.

Zuarino: There's the incident at the library in Missouri where they wanted to ban your book, as well as Craig Thompson's *Blankets*. Where does the case currently stand?

Bechdel: My understanding is the library is reviewing its acquisitions policies, which apparently they didn't have before. But that sounds like a stalling excuse to me to get the book off the shelf and keep people quiet.

Zuarino: Over a flash of frontal male nudity or something like that.

Bechdel: I don't know, there is one explicit sex scene in my book, but it's a little crazy. It's sort of exciting too in a way because I feel it's very much about this moment in the evolution of the graphic narrative form where people don't know what to do with graphic novels, and there's this assumption that because they're illustrated they're going to draw children in. It's just part of that whole adjustment to what to do with these books and starting to think of them as a category.

Zuarino: Let's talk about today. You went to Angouleme this year for their comics festival. How does it compare with something like the NYCC?

Bechdel: I thought it was really intense and overwhelming, but *nothing* compared to this. It was like 10 percent of this, 10 percent of the intensity.

Zuarino: Intensity as in fandoms or . . .

Bechdel: Well, I only saw one person in costume at Angouleme. I guess they don't do that there. But there was a Batman statue. I took my picture next to it [laughs].

I think they might be a little more rigorous about what counts there as comics. I mean, there aren't any World Wrestling champions or a lot of *Star Wars* guys. What's that about? That's not comics?

Zuarino: There's another regular NYC convention whose ads have been reduced to just *"Girls Girls Girls!"*

Bechdel: Yeah, girls in their Princess Leia outfits.

Zuarino: . . . slave Leia outfits . . .

Bechdel: [laughs] I don't get it. Why would you want to be ogled by a bunch of fourteen-year-old geeks? Well, actually forty-year-old geeks . . .

Zuarino: You also did work with Jennifer Camper over the past couple years, like in the *Juicy Mother* anthology, where you contributed the two page "Oppressed Minority Cartoonist."

Bechdel: Oh yeah. I actually did that for *The Stranger*'s queer pride issue on special commission. That was *very* cathartic.

Zuarino: Do you feel that still applies to the work you do now?

Bechdel: No. I did "Oppressed Minority Cartoonist" at the pinnacle of my bitterness. But I can't tell you what it has done to my mood to have *Fun Home* get so much recognition. Really, I was getting pretty depressed there.

Zuarino: Especially at a big literary publisher . . .

Bechdel: I know! A great stroke of luck.

Zuarino: So *Dykes* has been going on for, what, twenty-five years?

Bechdel: Twenty-four. I try not to make it any longer than it actually is [laughs].

Zuarino: It seems like it rejuvenates itself through current events, which keep feeding it and feeding it.

Bechdel: That's really good to hear. I hope that that's true. I work very hard at keeping it from lapsing into torpor, and it's really easy for that to happen with a serial strip. I guess it's sort of an inertia thing. People have a certain expectation, and they want what they got, what they've had before, but if you keep doing that, it dies. You have to find a way to change it just enough, but not too much to startle people.

Zuarino: Do you see the strip ending in the near future?

Bechdel: I don't, but people are asking me that all the time now. I don't know why. Are they seeing something I'm not? Is it getting stale?

Zuarino: I don't think so, personally.

Bechdel: Well, it's true that it's not as financially viable as it would be to devote myself completely to books. It might be a smart thing, actually, but somehow I don't think so. I feel *Dykes* is like a steady investment. A municipal bond. It has supported me for many years, not just financially, but as a really great outlet—especially during the Bush administration. I think I would go insane without somewhere to vent this stuff.

Zuarino: When the Bush administration first came into power in 2000, the strip really took on a different tone than before.

Bechdel: I think it got a lot more depressing in 2000. I think that's definitely a turning point of despair in the strip. People used to complain and ask, "Why is everybody looking so old and haggard, and why are they all drinking? Why isn't everyone having sex anymore?"

Zuarino: In *Fun Home*, and a little bit in *Dykes*, you take on a very literary tone with Joycean and Homeric references. Do you see the graphic novel heading towards a literature classification?

Bechdel: Yeah, I think it's happening now. Like the whole *Time* magazine thing with my book. They called it the book of the year, not just the graphic book of the year, but the *book of the year*. It's kind of startling. It makes me very happy for graphic novel format just in the same way that I'm always happy that I get perceived as just a "cartoonist," but not a "lesbian cartoonist" like in the old days. That's how I would get boxed up.

It's a similar kind of thing at work, and I think because my book is so ostentatiously literary, that it's about literature, it got a lot of literary attention.

That wasn't my secret plan, but I think that's part of why it got more literary scrutiny. Other graphic novels have gotten that attention too, but it just sort of reached a crescendo with my book.

Zuarino: You mentioned in the Nerve.com interview that your next book will involve your mother.

Bechdel: [laughs] I shouldn't have said that. Now she's going to find out. Well, the next book is about relationships. What I really want to write about is *self* and *other*, which seems like a very vexing problem. I'm just interested in why people get into relationships. What is it that we want, and are there really other people or is it just me? And am I making this whole crazy thing up? Inevitably, if you're talking about relationships, you've got to talk about your mother because that's who your first relationship is with. So in that sort of incidental way, yes, the book will be about my mother, but it's not going to focus on her. She really has forbidden me to write about her [laughs]. I don't think you can really enforce that. Your mother is too much of your life to not be allowed to write about her.

Zuarino: You kind of wrote about her at the same time you were writing about your father in *Fun Home*.

Bechdel: I did try to keep her out of it as much as I could, but there are more things I would like to say there.

Zuarino: How did you get started in comics?

Bechdel: [laughs] I never really got into the industry. I lived in the margins of the industry for my whole career. But I grew up with *MAD* magazine. That was a very big influence graphically, and that whole satiric sensibility. Edward Gorey was a big influence, Charles Addams. And then when I was older, like after college and after I came out as a lesbian, I discovered things like Howard Cruise's *Gay Comix*. That was a pivotal moment because I discovered all these gay and lesbian cartoonists who were writing about their own experiences. It made me realize I could to that too, and that's when I started my strip. But it was the early eighties, and comics were geared *more* towards little boys than they are now, so it never occurred to me to try to pursue a career in the comics world.

There was this gay and lesbian literary world starting up with small presses. That seemed like the natural fit for books and collections of my strip, and I'd publish in gay newspapers. So I just had this parallel existence in that world until now with this divergence with *Fun Home*. And now I'm at all these Comic Cons! Angouleme and here . . . and I'm going to go to San Diego . . .

Zuarino: What papers do you publish in, by the way? I've never really been able to find them.

Bechdel: There are about forty or fifty papers around the country. It's a constantly dwindling number, probably closer to forty now. They're all folding. They're struggling, and so is gay and lesbian culture. I think gay papers are having a harder time. When you get down to it, there's not really a need for it anymore. I know it sounds kind of elitist, and I know not everyone's as tolerant as they are in NYC, but really there isn't the same kind of necessity for those papers anymore, so they're disappearing. And New York has always been a very difficult venue, I don't know why. It was in the *New York Blade* for a while, but I don't know what the deal is with them.

Zuarino: I never heard of the *Blade*.

Bechdel: See? There you go [laughs].

Stuck in Vermont—Alison Bechdel

EVA SOLLBERGER / 2008

From *Seven Days Magazine*, December 13, 2008. Reprinted with permission.

Vermont-based cartoonist Alison Bechdel talks about fame, her twenty-five-year-old comic *Dykes to Watch Out For*, and her celebrated novel *Fun Home* while explaining why the personal has always been political for her.

Bechdel: I love words. But I especially love words and pictures together in a mystical way that I can't even explain.

Sollberger: Welcome to *Stuck in Vermont*, brought to you by *Seven Days*. My name is Eva
Sollberger. We are here in the wilds of Burlington, Vermont, to talk to cartoonist Alison Bechdel.
Cut away to **Bechdel:** I usually draw myself, so I'll just go with that.

Sollberger: She has been drawing the comic strip *Dykes to Watch Out For* for about twenty years and a compilation of her work, *The Essential Dykes to Watch Out For*, was just released.
Cut away to **Bechdel:** The characters in the comic strip are like my friends, my imaginary friends.

Sollberger: In 2006, she published the novel *Fun Home*, which received widespread critical acclaim. It was the number one book of the year by *Time* magazine. It was on the *New York Times* bestseller list for weeks and it's now being made into a Broadway musical.
Cut away to **Bechdel:** I can't be the oppressed underdog anymore. I have to suck it up and change gears.

Sollberger: What you might not know about Alison is that she can do a mean push-up and I can't.
Cut away to **Bechdel:** Wanna try it?

Sollberger: [Laughs]
Cut away to **Bechdel:** You do suck in fact. I always have to look on the negative side of things. I keep gnawing doubt at every step. I really put out so much of myself into my work. It's totally magical. Yeah that's the funny part: it gets turning in on itself. Wait. What am I talking about? Who knows? I don't know.

MAINSTREAM ACCEPTANCE

Bechdel: When this very glowing review of *Dykes to Watch Out For*, of *The Essential Dykes to Watch Out For* came out in the *New York Times* a couple of weeks ago, the first thing I thought of was I remember reading the *New York Times* in the eighties every day and it was so infuriating because they would never use the word "gay" or "lesbian." They would always say "homosexual." And now here are my freaky, queer lesbian cartoons in the *New York Times*.

LIFE OF A CARTOONIST

Bechdel: I always drew. I just never stopped. Most children stop. Here's a character of Richard Nixon that I made when I was twelve. I loved making these things that said "Keep Out" and I had this whole fixation on muscle men. This one says, "Muscle bound stupid head of the year." Talk about repetition compulsion.

PERSONAL IS POLITICAL

Bechdel: That's my middle name "Personal is Political. Political is Personal." I didn't really become a political person until I realized I was a lesbian. I was just this oblivious, middle-class white kid who didn't understand the structures of power or oppression or anything. My very existence became politicized for me, and that's what made me see all these things.

THE GAY MOVEMENT

Bechdel: It wasn't just me. It was a whole cultural movement that was also doing those things I was a part of. I said, "I'm going to write a comic strip."

Mo and the characters of *Dykes to Watch Out For* from *Essential Dykes to Watch Out For*

They said, "What's it called?" I said, *"Dykes to Watch Out For."* You know, I'm earnest. I'm twenty-five years old. People just look at you like you're a crazy person, like I was a pornographer or something. And then it started to shift. The subculture that I'd been a part of was starting to assimilate. Assimilation started to happen. People wanted to be like everyone else.

DYKES TO WATCH OUT FOR

Bechdel: It came out of nowhere. Here it is. It says, "Marianne, dissatisfied with the breakfast brew." And I wrote, "Dykes to Watch Out For, Plate No. 27." It was sort of this androgynous form: there's the girl part of the op ed and the boy part of the op ed column. I did *Dykes* as a way to make space for my own self. I created these characters to be my community, to be my fantasy community that I never quite felt that I had. I still somehow felt cut off, like I was missing the action. It wasn't like I knew what it was going to turn into. And by the time I was thirty, I was just able to quit my other jobs and just be a cartoonist. I got a lot of recognition in the gay and lesbian community, but I kept thinking I would somehow cross, get a bigger readership. And it didn't happen . . . until . . . it's starting now to happen now that I've quit, which is ironic.

First panel of "Coming Out Story" for Oberlin College LGBT Community History Project

FUN HOME

Bechdel: *Fun Home* was a story that was simmering in my head for twenty years, ever since my father died when I was nineteen. I feel like the story of my father and me is very much a political story because it's the story of two generations of gay people. My father was gay and I was and we both grew up in the same little Pennsylvania town. He killed himself and I became a lesbian cartoonist. It's in Czech—my name is Alison Bechdelova. It's in Korean, Spanish. Here's a Portuguese, Italian, German. There's simplified Chinese and then there's complex. I feel like it's not even me. . . . Although it is.

FAME AND RECOGNITION

Bechdel: It's very disconcerting. It was disconcerting when it happened with *Fun Home*, but I took some grim comfort in saying to myself, "Well, nobody's recognizing my *Dykes to Watch Out For* work." But now that this book is out, it's getting a lot of really good attention too. It's kind of freaking me out. Now what?

STRENGTH AND THE NEW BOOK

Sollberger: Why the strength thing? Why do you work out all the time?
Bechdel: Fear of intimacy? [Laughs]

Sollberger: That's the answer for everything.
Bechdel: [Still laughing] It is.

Sollberger: I use it too.
Bechdel: No, it's a fantasy of self-sufficiency. I have this thing . . . I shouldn't talk about this because I'm writing a book about it. But I feel like if I can hoist my own weight, that's a real indicator of my being able. I could drag myself out of a pit. I wanted to be strong, invincible, and invulnerable.

WHY VERMONT?

Bechdel: Vermont attracts a certain kind of person. You know? Someone who doesn't mind suffering and struggling and shoveling. [Laughs] I just love it here.

Cuts away to **Sollberger:** Well, that's it. I can't wait to see the Broadway production of *Fun Home*.

A Conversation with Alison Bechdel

ROXANNE SAMER / 2010

From *Gender Across Borders: A Global Voice for Gender Justice*, February 23, 2010.
Reprinted with permission.

Cartoonist Alison Bechdel is the author and artist of the twenty-seven-year-running comic strip *Dykes to Watch Out For* as well as the graphic memoir *Fun Home: A Family Tragicomic* (2006).

 Dykes to Watch Out For chronicles the lives of a group of lesbians living in an unnamed all-American college town. The strip is fun and fresh, combining witty political banter, insightful cultural commentary, and juicy relationship drama into an utterly delightful read. I was first introduced to *Dykes* in a women's studies course in college and found it quite productive for initiating discussions about gender equality, sexual relationships, and American society's treatment of all things "other." Perhaps equally important, it was a blast to read, and I was soon introducing it to my unenlightened friends. How could anyone not fall for Mo, Lois, Sydney, Sparrow, Ginger, and Clarice as they joke and tease one another over tofu tartar at Café Topaz, march on Washington for LGBT rights, and sell feminist lit, lesbian erotica, and Venus Willendorf coffee mugs as employees of Madwimmin Books? A compilation of the strip's best and brightest episodes from across the years, *The Essential Dykes to Watch Out For* (2008), is available from Houghton Mifflin Harcourt Press for those interested in rehashing these decades of fun or others wanting to catch up.

 Fun Home, though penned by the same hand, is much different project. In this autobiography of sorts, Alison introduces readers to her childhood growing up around the funeral home that her family ran in their small Pennsylvania town and the simultaneously discovery of her passion for drawing and love of women. She recounts how coming out in college provoked the revealing of her father's own homosexuality, and the narrative traces the intersections of their comparable and yet very different struggles in facing their sexualities.

The complexity of her storytelling, which intricately balances words and images as they play off each other in nuanced ways, is remarkable. The years of work that went into designing, writing, and drawing these pages are palpable and the sincerity of the story, in my opinion, unparalleled.

Named the Dedmon Writer-in-Residence of 2010 by the Committee on Creative Writing at the University of Chicago, Alison was in Chicago last week in order to give a lecture in Hyde Park, in which she spoke extensively about her creative process. Having learned about her visit ahead of time, I emailed Alison and was able to meet with her the day before her talk. Below is a transcript of our conversation, which touched on both the projects named above as well as her upcoming book (working title: *Love Life: A Case Study*), the creativity that autobiography allows, how she came to stop using color, her take on academia and its recent attention to her work, and much more. It has been only minimally edited for the sake of brevity. Enjoy!

Roxanne Samer: For me, your work really embodies the feminist mantra "the personal is political . . ."
Alison Bechdel: Yeah! Right on!

RS: . . . and I have heard you refer to "the personal is political" as "your middle name." I was wondering if you could talk about your politics and how you became politically aware and active and how this melded with your creative process.
AB: That's a nice light little question to start off with (laughs) . . . I didn't really have a political consciousness until I came out as a lesbian when I was nineteen. You know, I was just like this oblivious middle-class white kid and never had to deal with difference of any kind until I had to face my own. This was in 1979/1980, and it was a very politicized moment in gay and lesbian culture. Everyone was really analyzing the roots of homophobia and connecting it to every other possible kind of oppression, and it all just made beautiful theoretical sense to me. I liked it a lot. And, it's funny talking about this now that I'm so old and jaded. Yeah, I wasn't one of those people who was a feminist first. I mean, I was sort of always instinctually a feminist, but I wasn't an activist in any way. And I still don't think of myself as an activist, but I guess in a way my work has been a kind of . . . well, it's partisan. It definitely comes from a particular political viewpoint.

RS: A lot of your characters in *Dykes to Watch Out For* debate about what it means to be politically active—if it can just occur at the level of lifestyle

choices and being open or whether one regularly goes to marches, such as those in DC in the book . . . How much do these characters reflect real people or the ways in which you were involved in a movement or group?

AB: Well, yeah. I was very engaged with the general conversation that was going on about all these things—about what constituted activism, what our responsibilities were, what it means to live in this country . . . People talked about it. I know young people are still political, still activist in probably a different way than my generation was, but I do feel like it was all much more on the surface. We were just figuring this stuff out, stuff that you guys grew up knowing [laughs].

RS: Yeah, no definitely [laughs].

AB: So, it was exciting and explicit conversation that everyone was having. I wasn't so much trying to reflect that in my comic strip, but it just interested me, so it was naturally what I wrote about.

RS: Stepping back, how did you become interested in comic strips and graphic novels? I know you were writing and drawing at a young age. When did it materialize in that form?

AB: Well, I always did that. I always did it as long as I can remember. Like all children draw, but I never stopped. For a long time I just thought, "This is something I'm good at; I like to draw; I can do it," but I'm revising my theory recently. I think the reason I became a cartoonist is much more complicated and personal [laughs]. I used to think "my parents were really great! They both really encouraged me to draw and do my creative thing," and they did. They were very supportive in some ways, but in other ways my parents were both these sort of tortured, creative geniuses, who didn't really get to do their creative work. They would find ways to do it on the side, but they both had jobs—they both taught high school—but they had these wide-ranging interests. My mom was an actress and a pianist, and they both read lots of stuff. My dad did all this design and antiques and restoration work. And so my new theory is that I became a cartoonist because it was the only little creative swath that neither of them had claimed, and that they wouldn't scrutinize or judge, because I felt a lot of judgment coming from both my parents.

RS: I remember a part in *Fun Home*, where you're coloring in a coloring book and the crayon is supposed to be a specific color [and your dad took the crayon out of your hand and attempted to "fix" it] . . .

AB: That was a very traumatic moment!

RS: Is that why you don't use color any more?
AB: Yeah!

RS: Really?
AB: Yeah! My dad was like a color maniac, so I just decided, I don't need color! I'll just live in a black and white universe! Yeah, cartooning was a way to just dispense with color.

RS: I imaging in regards to comic strips and graphic novels, you must get some readers or fans who are coming to it because they're familiar with and accustomed to the form, but then there are also a bunch of us, including my-self, who found out about it from feminist friends or gender studies courses and are interested primarily in the content and this is our introduction to graphic novels.
AB: That's so funny!

RS: Does that bother you?
AB: No, I mean it's a bit of a new thing. Originally, people didn't talk about graphic novels when I was getting started [laughs]. It was like, okay, these are cartoons, we know what those are. And it was mostly this movement audience that was following them, so they were coming for the content and the form was just incidental. But now people will come up to me and say, "Oh *Fun Home* was the first graphic novel or comic of any kind that I ever read," and that's really cool! I love that! But it's funny to me that people don't read comics. Doesn't everyone read comics?

RS: So, *Dykes to Watch Out For* . . . you've been writing the strip since 1983? Is that correct?
AB: Yeah.

RS: And you stopped or paused in 2008? Could you tell me more? Is it over?
AB: Well, it felt kind of disturbing to hear you say that. I've really kind of avoided saying definitively that it's over. I don't know. I just . . .

RS: I remember last fall when I heard you speak at the School at the Art Insti-tute, you were talking about needing to pause, maybe just recently, because of the political climate—the election between Clinton and Obama. Did having to grapple with those sorts of issues have a part in it or was it just the narrative [of the strip] itself?

AB: I remember being kind of relieved that I had quit before the presidential race really heated up, because there were so many issues that really needed to be examined closely. It was this whole complex . . . race and sex and everything. I just didn't have the brain cells to figure that out in the way that I would have liked to in the comic strip and add the other work that I was doing for this memoir. But that wasn't why I quit. I made that decision earlier just because I couldn't do it. I had a lot of time pressure to churn out another book, which I'm very behind schedule on even having set the comic strip aside. But I guess my interest just shifted. I feel bad. I just left the strip off in midair. I didn't resolve anything, and I do intend to at least tie things up. I hope to have the time and energy to do some kind of little novella . . . just some little finale like *The Brady Bunch Christmas Special* [laughs] . . . But I don't know . . . I feel bad, Roxanne.

RS: I didn't mean to make you feel bad! There's so much for me, for many of us who are just discovering your work in these last few years to go back to and read and reread. They warrant many readings anyways.
AB: I just kind of lost my mojo . . . Maybe I'll get my mojo back!

RS: Do you ever think about what your characters would have said when you, say, listen to the news? I guess, I'm mainly thinking about Obama's recent move to repeal "Don't Ask, Don't Tell." I don't know, do you ever wonder what Mo would be saying? What's your relationship with the characters?
AB: Honestly, I know this is a disappointing answer, but I don't really think about them that much.

RS: Oh, really?
AB: Yeah [laughs]! Even when I was in the middle of doing the comic strip, I didn't really think about them except when I was writing and would use them as different arguments and points of view on an issue . . . You know, I think a lot of my mission in the comic strip was . . . I was interested in talking about politics, but my main goal was just to show that lesbians are like regular people. And I stopped feeling the need to do that. I feel like that at a certain point that had become established in the culture. I mean that was also at a point in which my cast of characters expanded. Stuart, the straight man, came in, and all this stuff. I don't know. I don't really understand how I could have stopped it all so abruptly and why I am not really thinking about it except that I've been very caught up in trying to do another autobiographical adventure,

and I find it very all-consuming. I don't mean this in a self-disparaging way, but I kind of got tired of the constraints of the comic strip. It's a very, very rigid form. It's a set physical space. It's a set interval. I have only so much room to make a small argument or show a small drama. You can do a lot of things in a serial comic strip. There's a lot of potential there. But in a way, I kind of feel like I wasn't able to do the creative stuff that excites me, so I'm trying just to follow what my excitement is about, and it's for bigger stories that can't be contained in single episodes.

RS: Yeah, you definitely gained flexibility with *Fun Home*. It's a totally different project. The lack of linearity . . . I mean, something is propelling the story forward, but you are continually jumping back and forth through time.
AB: Yeah! I love trying to find that propulsion—what is that thread through which the events of life [can be connected]. I love trying to find that and put it down. And with the comic strip, I would always know what I would be doing ahead of time. There was not a lot of surprise. I would know what was going to happen, what the issues were, and it was fine. This [*Fun Home*] is more adventurous. Autobiography is more adventurous in an odd way. It seems almost counterintuitive—you know what happens in your life, but for me it's more exciting than writing a fictional world.

RS: I'm always amazed by all the memories you are able to come up with. Maybe some of us just tend to block out more of our childhood. Are you continually re-remembering? Is it because you kept so many journals? Or are you just *really* smart [laughs]?
AB: No [laughs]! I did keep a lot of journals. I'm very sort of bogged down and confused in the current memoir that I'm working on just *because* I have so much material. I've got letters—I used to make copies of my correspondence, so I have letters I've sent to people. I have my diaries. I have datebooks, which were separate from my diaries, in which I would write down everything I did every day, I have letters other people sent me [laughs]. I have files and files of just ephemera—ticket stubs, fliers and shit that I collected. I have photographs. And, as I've gone through life, this just keeps multiplying and replicating. My journal will refer back to earlier journal entries, and it just gets incredibly self-referential and confusing! And I guess that's in part what I am writing about—why do I have this strange compulsion to keep it, to hang on to life, to somehow keep track of the flow of life? Why can't I just let it flow? I haven't answered that question yet, but I'm working on it.

RS: This next project is about relationships, right?

AB: Oh, god! I wish I knew what it is about! The working title is *Love Life: A Case Study*. And it was . . . [laughs] . . . I'm kind of reorganizing the whole book right now, so it's confusing to talk about. It really is a memoir about my relationship with my mother. It's kind of a companion book to *Fun Home*. My dad was dead, so it was pretty easy to write a book about him, because what would he know, what would he care? But it's really hard to write about my mom, knowing she's going to see it. It has been an incredibly challenging thing to grapple with. I was avoiding that for a couple of years. I have been working on this project for several years, and I finally realized the great lengths I've gone to in order to avoid talking about my mother and that I need to just jump in and do that.

RS: Is she fine with that?

AB: I would not say she's fine. She's remarkably understanding, but it doesn't make her happy.

RS: [In *Fun Home*], at the moment she decided to share with you about your father and his life, first on the phone and then in person, you say it was the first time she spoke to you as an adult. Has creating this book and talking about your dad's life opened up a dialogue or developed your relationship [with your mom] at all? Or has it just been difficult?

AB: I think it's difficult to say. I think it has, but not in the way I sort of fantasized that it would. We all imagine these warm reunions with our distant parents and that hasn't exactly happened. It certainly is a way of connection with her just not the neat, tidy one that I imagined. But I keep pushing at her, I keep saying, "Look Mom, I'm writing this book . . . it's going to have some stuff about you in it," and she doesn't really want to see it or be involved. I think the less she knows about it, the less implicated she feels. She can just say, "That's my crazy daughter writing whatever comes into her head," but that's okay.

RS: And your brothers?

AB: I would not recommend writing a family memoir if you want to get closer to your family members [laughs].

RS: Yeah [laughs].

AB: One brother is fine with it. One brother has a hard life, and it's frustrating for him that I get to do the thing I love.

RS: But it took years, right? At least to have this creative freedom to work on these projects?

AB: Yes! Yes. Thank you. It did.

RS: Perhaps my favorite part in *Fun Home* is the section in which you start keeping a journal and eventually start inserting "I thinks" into your writing. You have this epistemological crisis, where you are not sure, you become uncertain in your own truth. But what I think this work embodies is the fact that you've grappled with this and told your story in a beautiful, amazing way . . . There's a certainty to it . . . I forget what my actual question is . . .

AB: Well, it's funny that you say that, because with the "mom book" that I'm working on now . . . I know that writing *Fun Home* was an achievement. It was overcoming that self-doubt that I wrote "I think" after everything, but I'm *still* doing that! I'm *still* struggling. I guess, the mother aspect of the critic inside my head . . . with *Fun Home* it was the father aspect . . . They were both so, I don't know . . . Criticism was the atmosphere that we lived in, and not necessarily negative criticism, just observant criticism.

RS: But they both seemed to have a hard time with it as well—your father needing to change his tie if someone made a comment or your mother not wanting to know when you were coming to her play performances [both scenes from *Fun Home*].

AB: Yeah, good point!

RS: I mean, even if she's there in your head or your conversations, is she able to relate to your stress over the project? Or because it's personal . . .

AB: No, I think she does kind of relate. Oh, god [laughs]!

RS: I'm sorry. I didn't mean for this to turn into a psychoanalysis session with Alison Bechdel!

AB: Well, I'm sort of psychoanalyzing myself in this book, which is why it's taking me so long—the book about my mother.

RS: You said you're rearranging it now? Could you talk about your creative process? When do you work with the words? When with the pictures? When do you put them together? Do you have whole panels that you are rearranging, whole completed sections that are now being reshuffled?

AB: There's going to be some major shuffling. I write in a drawing program, Adobe Illustrator, so it's not like I'm freehand writing down and sketching

pictures. I think about the writing process as a kind of drawing, though. I'm moving things around on the page. I'm thinking visually. Sometimes I'll plop in an image from the web or something I've sketched or scanned, but I'm not actually holding a pencil in hand. It's mostly typing words on the keyboard and moving them around the little boxes on the page, because for me drawing is such intense work that I don't want to have to redo it. If I draw a whole scene and it turns out I need to delete this panel, everything has to be redrawn.

RS: So you tend to work first with words?

AB: I guess I do. I always balk at saying it that baldly, because it isn't just words in a word processing document. It's words in a two-dimensional field, words as a drawing element, as a design element. But, yeah, it is primarily the words for me. I mean, sometimes I'll get stuck with the writing and I'll think, "What's the next image?" and that will pull me through. But more often my process is led by the text.

RS: I would like to ask you about academia. Obviously a few of your characters in *Dykes* are professors, your parents were both teachers, you give talks at schools, and much of your use of language seems to come from an intellectual environment, but there's also a humor to it. You poke fun at academics in your work too, perhaps most noticeably in the titles of the books the characters are reading, the dissertations they're working on, etc.

AB: I feel like if I had had my shit together more when I was in college, I probably would have become an academic. If I wasn't so insecure and if I hadn't been so afraid of speaking my own perspective. Both of my parents could have been college professors, but they were teaching high school, because for various reasons they couldn't push through to work at a more intense level, the demands that that would make. I feel like we're all—my parents and me—college professors manqué. So I guess I live out the fantasy, what life might be like as a professor. I love campuses. I love the idea of academia—a community dedicated to knowledge in this little cloistered world. I love that. I just want to be in that, but I'm not. In many ways, I'm glad. I could never sit on committees. I'm not that kind of person, so it's probably just as well that things worked out the way they did.

RS: And how do you feel about your work being taught in the classroom?

AB: Well, I'm delighted of course. It's kind of funny. If I had sat down with both hands to write a book that would be taught in college classes, it probably would be *Fun Home*. It works for gay and lesbian curriculum. It brings in

all of these English class classics. But that wasn't my intention. I don't know. We will see if it persists. It might just be a blip, but it's kind of cool right now.

RS: Yeah, I think it's great. It's fun to read alongside other writing. In my case, I first read *Dykes* in a women's studies course, so we were reading a lot of feminist theory. To bring this pleasurable material in . . .

AB: Yeah, I know reading other kinds of stuff is pleasurable too, reading really dense ideas and stories is its own pleasure, but I do feel like . . . I don't have the greatest attention span in the world. I want to make something that is easy to read. I want to get as much information and experience into a package that is as accessible to read as I can. I guess that's what is changing with *Dykes to Watch Out For* . . . for a comic strip there's a lot substances to it, there's a lot of issues and nuanced stuff going on with the characters, but it's still a comic strip. It's still coarse, and I want to work at a slightly finer level of getting more information, more ideas, more complicated ideas into a package that is still accessible, easier to read than not to read.

RS: I just want to check . . . How long has it been? Are we almost out of time?
AB: Oh, yeah, we should probably wrap up.

RS: Okay, lastly, this interview is for a blog, and I know that you have your own very well maintained website with a blog component. Can you tell us what you do there, what we can find, what sort of work or insight to your work is provided in that space?
AB: I've actually been feeling kind of conflicted about the blog, because . . . I mean, I like it. I like having a place for readers to get together. I love the community that readers have formed there. But I am not making posts very frequently. I was when I first started. I might just have blog fatigue like everyone gets, but also I feel like it was kind of sapping my autobiographical juices, which I need to put in this other project. Blogging is wonderful, but it's a certain kind of writing. It's not seasoned. You haven't sat with something and refined it over and over. It just comes out, and then it's gone [laughs]. So I'm not doing so much blogging lately, just kind of doing minimal amount of posts to keep a connection going.

RS: Could it perhaps become another way that you keep track of your life?
AB: Totally! It totally is! It has become like an appendix to my journal. I'll think, "What was that idea I had?" and I have to go search my blog for it. So that's kind of funny, but also, who wants their journal up, out in the ether?

RS: Well, if anyone would be comfortable with it, I think it could be you [laughs]!

AB: Ha! Well, that's a good ending note, Roxanne [laughs].

RS: Well, thanks so much for meeting with me!

AB: Yeah, thank you.

RS: It's been a pleasure.

AB: It has.

Writers on the Fly: Alison Bechdel

IOWA CITY UNESCO CITY OF LITERATURE / 2010

From Iowa City UNESCO City of Literature, www.iowacityofliterature.org, December 27, 2010. Reprinted with permission.

Iowa City UNESCO City of Literature, Humanities Iowa, and the National Endowment for the Humanities present *On the Fly: Writers on Writing*. This episode: Alison Bechdel.

Q: What is the question most commonly asked by your readers?
A: A question I very commonly get asked is what comes first: the writing or the drawing? And it's always very complicated for me to explain that and I find that sometimes I can't really explain that without showing pictures [laughs], because that's how my mind works. I always have to make things visual. But I will try and do it verbally and . . . the writing . . . it might look to an external observer that I am writing first then drawing because I do sit at my computer and I do write everything out before I do actually put pen to paper. But what I'm doing at the computer is writing in a two-dimensional field. I'm writing in a drawing program. So it's not like a word processing program where I'm just typing across the page, but I'm actually moving text around the page, designing the page, placing images or sketches, moving them so that I have a sequential story being told on the page. So even though that's not actual drawing with a pencil, it feels to me like a kind of drawing. So my writing and drawing are kind of mixed up together; that's the answer.

Q: Do you have a favorite quiet place?
A: My office, where I work, where I spend most of my life, in the basement of my house. I'm so happy to be able to work in my home and it's very quiet. I live in the country, so it's just woods and very quiet. I love it.

Q: What are the hardest environmental circumstances in which you were able to get work done?

A: That's an interesting question. [Laughs] Well, I remember once I was on a deadline; I had cartoons that I needed to, I had a book deadline and I had to finish all this drawing for it. I also had to go attend a big outdoor music festival, the Michigan Women's Music Festival, which was this big lesbian gathering. Well, it still happens, but this was many years ago. And I would go there to sell my comic books. I did this lesbian comic strip for many years and I would sell my comic books and t-shirts and stuff. So I had to go do that, but I also had to draw, so at night in this very dark, dank tent, with a lantern and mosquitoes swarming around me, I would have to do my inking. That was probably the most extreme circumstance.

Q: Is there a work or author that is a strong influence on you right now?

A: I guess I would have to pick a children's book that affected me very strongly as a child and that was *Harriet the Spy*, which is kind of a book about being a writer. Should I expound a little more on that?

Q: If you want to.

A: I must have read that book twenty or thirty times as a kid. It's about this little girl who keeps a diary and she doesn't let anyone else see it. She's always writing notes on everyone around her . . . She has a spy route she goes on after school and takes notes on all the people who live in her neighborhood and I just love this idea. But then her friends, somebody gets ahold of her notebook and all the kids read what she's been writing about them. They all turn on her and she has to go to a child psychologist. I always wanted to go to a child psychologist. [Laughs] Anyhow, that was a very formative book for me. And I did grow up to become a writer.

Q: How do you recharge your batteries?

A: I recharge my batteries by going out and walking in the woods around my house. I can just step out the door and I'm in the woods. I have a brook that goes by; I love to follow the brook and explore that. It's funny that you would ask that. I mean, I know to recharge batteries is an expression everybody uses, but my girlfriend just sent me a video like ten minutes ago of the brook and other nice little things, to show me that the brook was still there. And I felt immensely recharged by just looking at this video. So it's very soothing. Also, I feel like I often solve story-telling problems walking along the brook

because, you know, it has this order. It's always moving forward and you always want to see what's around the next bend. There's this suspense to it that I find inspiring.

Q: Is there a word or phrase you always cut?
A: I know I tend to use a lot of self-deprecating disclaimers that I am suddenly noticing that I'm working very hard to eradicate from my writing, as well as my speech. But you know, just apologizing for, uh . . . I'm not thinking of any examples. I'm sorry.

Q: It's ok.
A: See, I'm doing it. [Laughs]

Q: Is there a spiritual dimension to the work of writing?
A: Yes, there is. Actually today, in the talk that I gave, I talked of memoir as a kind of religious practice for me because it involves a leap of faith on my part that my life is a meaningful story. I don't believe intellectually that my life has meaning whatsoever, but it's like Pascal's Wager. I find life more pleasurable if I believe that it has meaning. Therefore I choose to believe that it has meaning and to write about that meaning. So that's more religious than spiritual. Spiritually, I feel like as a memoirist, what I'm doing is observing my own self in as minute of detail as I possibly can and sometimes that feels like just so monstrously selfish and self-absorbed and nauseating. I can't bare myself. And yet I do it. I do it because I feel like my self is a way out of myself, my individual self. That it's a way to connect with other people. And so in that sense it has a more spiritual dimension too.

Q: Who is a writer?
A: Well, I guess I would say a writer is anyone who is . . . not just experiencing their life, but . . . observing it and . . . observing it with something to say about it. So that probably is like most members of the human race. [Laughs] Maybe I should qualify it a little more. Not only are they observing it, not only do they have something say about it, but they're actually going to the considerable trouble of saying it in some form or other.

The Rumpus Interview with Alison Bechdel— Sections II–X

MARINAOMI / 2012

From *The Rumpus*, marinaomi.com, May 30, 2012. Reprinted and edited with permission.

Alison Bechdel is a living legend (and this from the point of view of a queerish autobio cartoonist). Not only did she create the long-running *Dykes to Watch Out For*, a comic strip that followed the hijinks of a group of friends (and also where the "Bechdel test" originated—look it up!), she also penned *Fun Home: A Family Tragicomic*, a graphic memoir about her relationship with her father that won lots of awards and hit the *NYT* bestseller list—and stayed there for two long weeks. That's a huge feat for any writer, but a cartoonist who also happens to be a queer woman? Forget about it!

Alison's new book, *Are You My Mother? A Comic Drama*, is hot off the presses with a May 1 release date, and she was kind enough to chat with me at a café in San Francisco's Union Square in the midst of her book tour.

II. *DYKES TO WATCH OUT FOR*

Alison Bechdel: I started some little furtive forays into autobiography in *Dykes to Watch Out For*. It felt like it was wrong at the time. I knew it was sort of inappropriate. For the most part it was not an autobiographical strip, but there were definitely some episodes that my life did work into it and that was kind of a breakthrough for me when I started doing that, because it felt like the tone of the strip changed and became much more—I want to say "intimate" but I'm not really sure what the right word is. The writing got more complex. The relationship between the characters got more complex because I realized that I could write more like what my real life was like. Before that, it had been pretty much a sitcom kind of deal. So yeah, there were these little forays into autobiography . . .

The Rumpus: Did you ever get in trouble for it?

Bechdel: My girlfriend at the time did not like that I had drawn this character that kind of looked like her, but it was really just her appearance that I copied. I didn't use much else about her but I did work some of the circumstances of a bad breakup that I was going through into the comic strip and [laughter] I don't know, it helped my writing. It made my writing more complex and it planted the seed that ultimately I would like to really just write about my life straight up, without the fictional veil.

Rumpus: Do you miss the strip at all?

Bechdel: Honestly, I don't. I feel like I'm really proud of it, I loved doing it, I had a great passion for it for many years but I just lost the impulse I had to do it. I feel like there was not the same need for it that there had been originally. I feel much more passionate now about memoir; I feel like I need to pay attention to that, do what I feel like doing.

Rumpus: You were doing that for a long time, weren't you?

Bechdel: Yeah, I was doing the strip for twenty-five years!

Rumpus: Wow.

Bechdel: I know, it's crazy!

Rumpus: You'd have a pension plan by now if that were a government job.

Bechdel: That'd be a good government job.

Rumpus: Or a watch.

Bechdel: Yeah, unfortunately, no pension plan.

III. *FUN HOME*

Rumpus: When you sat down to conceptualize *Fun Home*, what were your intentions and how did they change as you wrote it—is the book what you visualized when you went into it?

Bechdel: No, when I went into it, I had no idea what I was doing. From day-to-day, I had no idea—it's like I was inventing as I went along, I was inventing my method. I had no idea what it was gonna look like, how I was gonna do it. I knew the story of course, I knew the basic story about my dad, but it was a total process of discovery of how to tell it. And it took years.

Rumpus: How long did it take you to write?

Bechdel: The whole thing took about seven years. And this latest one took six years.

Rumpus: Quick!

Bechdel: I just saw Chris Ware, and he has a book that he's working on that took him ten years, and he has this ratio. He'd figured out that the time it takes to create a comic—have you heard this?

Rumpus: No.

Bechdel:—to the time it takes to read a comic is four thousand to one.

Rumpus: That sounds about right.

Bechdel: Yeah.

Rumpus: It took me eight years to write my book and it takes three hours to read it. I timed it.

Bechdel: There you go! That sounds probably higher than four thousand to one.

Rumpus: People don't realize, IT TAKES SO LONG!

Bechdel: It's a really crazy thing to do.

IV. *ARE YOU MY MOTHER?*

Rumpus: So when you sat down to write *Are You My Mother?*, same question: how much did you visualize and—this is about to sound so pretentious—as a MEMOIRIST, I really appreciated reading *Are You My Mother?*, especially since I just wrote this book and it's actually about my sex life, but it's kind of about my dad, and the next book I'm work on is kind of about my mom, and it's like HOLY SHIT, ALISON BECHDEL! [laughter]

Bechdel: Really, those are about the basic things everyone writes their memoirs about. How could you write about anything else? Uh . . . What was the question?

Rumpus: I didn't get to it yet! There's so much that's different between the two books, did you feel like the process of creating the book was different—did you go in with a different idea of what it was gonna be . . .

Bechdel: I thought I had mastered my technique in *Fun Home*. I'd learned this visual language, I'd learned my personal kind of way of combining stories and pictures, and now I can keep doing it and it would go a lot quicker but it was

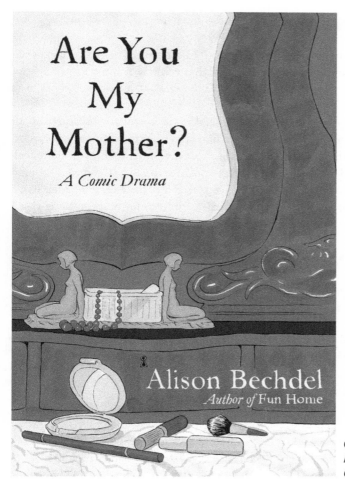

Cover of *Are You My Mother? A Comic Drama*

totally not the case. I feel like I had to relearn it all. And there was a certain amount of technical stuff I had to relearn because all the Adobe software is always changing . . . It's good to get pushed like that. I feel like I've gotten too reliant on other images and photographs, like I do this really extensive posing thing where I pose as all the characters from my book and then I draw . . . I would like to just use the drawing that comes directly out of my head, which is very different from the drawing that come from looking at something then drawing it.

[Note: Alison took approximately four thousand reference photographs for *Are You My Mother?*]

V. POST-*FUN HOME*

Rumpus: For me, [writing about my life is] a catharsis, I'm getting things out in order to examine them. Did you find that you had a different perspective after you wrote [*Fun Home*], or did you solidify what you already thought of the events?

Bechdel: I feel like I got a lot more empathy for my father. I researched the circumstances of his life, I understood him better. I wanted to write an honest book about both my negative feelings about my father and my positive feelings. In the end, my feelings were more positive. I had a friend who thought it was too sentimental, that I kind of copped out at the end. [But] I felt like it was pretty genuine. I do feel like I learned from my father something about being an artist, and I'm very grateful for that.

VI. SEX AND FAMILY

Rumpus: Has your mom read the new book yet?

Bechdel: Yeah, she's read it. I mean, I showed it to her as I was working on it. I felt like I had to do that so she wouldn't totally freak out, you know? I didn't feel like I could write about her without her seeing it. You can't just show someone a finished published book about them, it's really not fair.

Rumpus: Well, you can. I mean, *I* did.

Bechdel: Did you do that?! [laughter] What did your family say?

Rumpus: My mom read six pages of the book and then put it down and said, "I don't want to read this," which was perfect, and my dad, it took him about a year to get through it. I mean, he was disappointed I hadn't told him these things before, but I couldn't have, because our relationship was different . . . and now we're friends . . .

Bechdel: That's very . . . brave of you.

Rumpus: "Horrifying" is the word I think you're looking for.

Bechdel: Yeah, yeah . . .

Rumpus: And I can't believe that *you* just said that to *me*.

Bechdel: Well, I know I've written some sexual stuff in my books, and that's really excruciating to show my mother . . . but it's not like *you*. [laughter]

Rumpus: You are a little more detailed! I'm thinking of one panel in particular where I was like, WOO! [Mari makes a fanning motion, looks around, embarrassed.] [laughter]

VII. SELF-IMAGE

Rumpus: You look a lot more friendly in person than you do in your comic.
Bechdel: Really? My friends always say, "You never draw yourself smiling."

Rumpus: You look really intense and serious, brooding . . . in the comic.
Bechdel: I'll try to lighten up.

Rumpus: Why?!
Bechdel: Because I want to be honest.

Rumpus: But you're *being* honest about how *you* perceive *yourself*.
Bechdel: . . . That's true.

VIII. POST-PUBLISHING

Rumpus: So after you wrote *Fun Home*, after it got put out there, how did your views of these events change?
Bechdel: It was weird. The public perceptions of the book was a whole different phase. I thought I had finished the book and knew what I felt about it, but then it got a lot of attention, which was surprising. It was very successful. My family was not prepared for that. My family was suddenly much more exposed than they thought they would have been by the book, and that was difficult, and that was a part of the book somehow. That post-book material is something I felt like I had to write about in this other memoir. I didn't really do that so explicitly, but I mean, my life really changed when *Fun Hone* came out. I was doubtful whether I was gonna be able to keep cartooning. It was just getting really hard to make a living and *Fun Home* totally bailed me out and enabled me to keep doing this.

Rumpus: That's pretty awesome.
Bechdel: It was *totally* awesome! I feel like I've had really good timing, that I started doing this autobiographical work at a point where not just comics, but also memoir was becoming a publishing trend.

IX. REVIEWS

Rumpus: Do you read your reviews?

Bechdel: I read all of my reviews with *Fun Home*. And I've read some of the reviews for [*Are You My Mother?*], but not all of them. I just haven't had the time. I've also felt very vulnerable and exposed about this book in a way I didn't with *Fun Home*.

Rumpus: Really, why?

Bechdel: It just feels more intimate somehow. I'm also worried about my mother's reaction to reviews, especially if she gets named personally in a review—sometimes these people do that, they use her name and that freaks her out, which I totally understand, so I've been kind of nervous on her behalf as well as my own. But I feel really proud of myself because I got a bad review and I was really okay with it. I feel like part of why this book about my mother took me so long was that I was kind of toughening myself up. I knew it was very intimate, personal material, I knew it wasn't everyone's cup of tea, and I had to be able to take that kind of criticism. I feel really pleased that I'm okay, it did not destroy me. I feel like, "No problem!"

Rumpus: I had that same experience!

Bechdel: Really?!

Rumpus: Oh my god! I was doing this for so long, and I actually never thought I'd ever get any level of success . . . I was just copying ten zines at a time and I never thought anyone would ever see it. It's kind of like being afraid of success in that I don't want to ever read a bad review, so you're kind of afraid of success and being unsuccessful. That was my biggest fear, like when I had an art show I'd have a panic attacks worrying I'd overhear someone saying something mean about my art. But when it finally happened I was like, "Oh screw you, whatever!"

Bechdel: It's incredibly liberating!

[Alison high-fives Mari.]

X. WHAT'S NEXT

Rumpus: Future goals—in cartooning and life, what do you wanna do?

Bechdel: I just wanna keep drawing comics. Right now I still feel very passionate about memoir, I have more stuff I'd like to do about my family, although

I'd have to talk about that with them first. [laughter] I'm starting to think about the possibility of even some kind of fiction eventually. I always thought I wouldn't do that. I mean, *Dykes to Watch Out For* was—

Rumpus: It *was* fiction!

Bechdel: —but it somehow didn't feel that way, it felt more like a newspaper column or something, like I was reporting. But I want to focus more on my drawing. I want to build up my drawing skills, I wanna do more life drawing. I want to trust my inside drawing as opposed to looking-at-references drawing. I think I need to spend more time drawing and less time fretting about my writing. That's one of my goals.

Book News: A Q&A with Alison Bechdel, Cartoonist and MacArthur Winner

ANNALISA QUINN / 2014

The winners of the MacArthur "Genius Grant" awards were announced Wednesday morning and included poet Terrance Hayes, playwright Samuel D. Hunter, poet and Arabic translator Khaled Mattawa and cartoonist and memoirist Alison Bechdel. Bechdel is the creator of the cartoon strip *Dykes to Watch Out For* and author of the graphic memoirs *Fun Home* and *Are You My Mother?* Bechdel spoke with NPR by email on Tuesday afternoon.

Q: What made you want to become a cartoonist?
A: I wanted to become a cartoonist ever since I was a kid. I always loved drawing but I also loved words. I'd include random letterforms in my childhood drawings even before I could read. My parents subscribed to the *New Yorker*, and I learned how to flip directly to the cartoons, just past the Talk of the Town section. As soon as I learned there was such a thing as a cartoonist, I wanted to be one.

Q: How did *Dykes to Watch Out For* begin? And do you miss it?
A: But I actually gave up on becoming a cartoonist as I went through school. It seemed like such a long shot, and people tried to steer me toward something more realistic, like book design. But then I just started drawing *Dykes to Watch Out For* for fun, for a feminist newspaper I worked at. People responded really well to it, and I was desperate for attention so I kept drawing new episodes.

I actually do miss it. I drew that strip for twenty-five years, and I miss all the characters and their conversations about politics and what was going on in the world.

Q: For a long time, you've been a kind of rebel in the world of cartooning—what do these huge mainstream honors mean for you?
A: It is very strange that my work has been getting so much mainstream attention. I've been adjusting to it for a while now, ever since my memoir about my father, *Fun Home*, was such a surprising success. Now it's been turned into a musical and will open on Broadway next spring. And now . . . a MacArthur! It's amazing and I'm very grateful, but it's also a little strange. This sort of establishment recognition was never anything I envisioned when I started doing my odd little subculture comic strip over thirty years ago.

Q: What are your inspirations? You've talked a lot about *Harriet the Spy*—what does she mean to you?
A: Oh, god, *Harriet the Spy*! I read that book easily twenty times as a kid. At the time I just thought she was cool, bravely peeping through peoples' windows and creeping into the dumbwaiters and spying on what they were up to. But as an adult, I realized that she wasn't so much a spy as a writer, this archetypal writer taking notes on everything around her. When her friends find her, they're devastated and so is she. As a memoirist, I identify intensely with her peculiar dedication.

Q: What are you proudest of?
A: I guess I'm proudest of just really sticking with this odd thing I loved and was good at—drawing comics about marginal people (lesbian) in a marginal format (comics). I never thought much about whether that was responsible, or respectable, or lucrative. I came of age at the tail end of America's real prosperity, so I had the leisure, or imagined leisure, that I would be okay even if I did some kind of fringy thing. And against all odds, it has worked out.

Q: How do you gather the strength to write about such incredibly personal issues? Or, I guess, is writing about yourself hard? Do you have that anxiety that I think a lot of women writers have—that writing about yourself is somehow indecent or self-indulgent? And if so, how do you get past that?
A: In the case of me and my family, that was so vividly true. My bisexual father came of age before gay liberation. My mom who wanted to be a writer came of age before the feminist movement. They were both thwarted in their lives

in various ways. As I got older I could see that their personal frustrations were not just personal, they were part of much larger cultural and political structures. I just keep trying to understand those things and lay them bare. It does get very personal sometimes, verging on solipsistic. But I try hard to make my way back outside of myself to the wider world, and to share what I've figured out.

Q: Do you have a goal for your work—something in particular you want it to show or teach people?
A: Do I have a goal for my work? Once many years ago I wrote myself a "mission statement." It was "To unceasingly excavate the potsherds of truth from the sediment of convenience." I guess that continues to be my goal.

Lesbian Cartoonist Alison Bechdel Countered Dad's Secrecy by Being Out and Open

TERRY GROSS / 2015

From *NPR: Fresh Air*, August 17, 2015. *NPR: Fresh Air* with Terry Gross is produced at WHYY in Philadelphia and distributed by NPR. Podcasts are available at www.npr.org /podcasts and at iTunes. Reprinted with permission.

Terry Gross, Host: This is Fresh Air. I'm Terry Gross.

[soundbite of Broadway musical *Fun Home*]

Emily Skeegs: (As Medium Alison) Caption—my dad and I both grew up in the same small Pennsylvania town. And he was gay, and I was gay. And he killed himself, and I became a lesbian cartoonist.

Gross: That's the story at the center of the Broadway musical *Fun Home*, which won this year's Tony Award for best musical. It's adapted from the memoir of the same name by my guest Alison Bechdel, who first became known for her comic *Dykes to Watch Out For*. Last year, she was the recipient of the MacArthur Genius Award.

Alison didn't find out her father was gay until after she came out at the age of nineteen. After she told her parents, her mother delivered the shocking revelation about Alison's father. Alison's mother had always been aware that there were men in his life, but she'd stayed married to him in spite of that. His death came shortly after Alison learned the truth.

The songs for *Fun Home* were written by composer Jeanine Tesori, who also wrote the music for *Caroline, or Change*, and lyricist and playwright Lisa Kron. They're joining us, too. They won a Tony for best score, and Kron, who wrote the adaptation, won a Tony for best book of a musical. In the musical,

Alison is at her desk, writing her graphic memoir. And as she writes and draws, the action flashes back to the periods of her life and teenage years that she's illustrating. Three different actors play Alison at these three different stages of her life.

Her childhood home is an important part of the story. Located within it was the Bechdel Family Funeral Home, which her father had taken over. The house was a great source of pride for him because he'd renovated it and furnished it with antiques—collecting them was his passion. This scene from the cast recording begins with adult Alison at her desk, writing for a panel of her memoir about her childhood.

[soundbite of Broadway musical *Fun Home*]

Gross: Alison Bechdel, Jeanine Tesori, Lisa Kron, welcome to *Fresh Air*. Alison, let me start with you. What was it like when you first heard your story sung?
Alison Bechdel: I was kind of blown away. I was not at all prepared to hear the music that Jeanine and Lisa had made. I somehow thought a musical—you know, I knew the musical was happening. I was preparing on some level for it. But I thought it would be somehow lighter, a kind of arm's-length take on my life. But listening to these songs of people singing as my family was—it was just really visceral, just really hit me in the stomach. It was much more emotional than I had been anticipating.

Gross: So, your father was gay but very closeted. You came out at the age of nineteen. Do you think it's a coincidence that he was gay and you're a lesbian? What do you make of that?
Bechdel: [Laughter] Do I think it's a coincidence? I don't know. I mean, my family was certainly very odd in its psychological dynamics. But I do feel like in many ways, my life, my professional career has been a reaction to my father's life—his life of secrecy. I've been all about being out and open about being a lesbian since I came out in, like, 1980. It's been my career. I wrote this lesbian comic strip for many, many years. That was my job—a little bit to my family's horror at first, but they all got used to it, eventually.

Gross: You found out that your father was gay only after you came out at the age of nineteen. You were in out-of-town college. You told your parents by writing them a letter. After getting the letter, your mother told you that your father had had affairs with men throughout his life and that she had known all along. But did you have any clues that your father was gay?

Bechdel: I didn't. I mean, no, I was floored. I was—literally; I had to lie down on the floor when my mother told me that. But then I immediately started reviewing my entire life so far and, yeah, I started seeing lots of clues. My father was a dandy. He always wore kind of fancy clothes. He had more clothes than my mother did. He loved buying clothes for my mother. You know, and then all these stereotypical ways that he was, you know, gay—that he collected antiques. He didn't watch sports. He didn't go hunting. You know, he was kind of a stock character in a way.

Gross: What did it say to you about your mother that she managed to say in the marriage with him all those years knowing he was gay?
Bechdel: Well, my mother is a complicated person and a very, very duty-bound person. She—people didn't get divorced in our small Pennsylvania town. It just—I mean, it was starting to happen culturally in the broader country, but no one we knew did it. And she wasn't prepared to break up our family. I feel like my parents really are—they're kind of tragic figures. They both were ready to have different kinds of lives than were available to them in the culture. But they came along too soon. They both came of age before the women's movement, before Stonewall. They weren't able to take advantage of those liberation movements. They were already stuck, married, living, you know, in this tight-knit, little community. They didn't have a lot of options.

Gross: It doesn't seem like it was a very loving or warm marriage, judging from the book. In the musical, he would kind of order her around. He wasn't very grateful for the things that she did for him. Did you ever ask her what it was like for her in the marriage, knowing he was gay?
Bechdel: I don't think I ever asked my mother that directly. I was always very careful about what I asked her—you know, how much I was going to impinge on her privacy. She used to tell me a lot very freely in the years after my father died and before. At age forty, I started to write this book about him. She told me a lot. But once she knew I was writing about him, she sort of cut me off from that flow of information. I think she didn't want to be complicit in the project, although she made it clear that she understood that I had to do it, and that was okay.

Gross: So she didn't force you to choose between a relationship with her or doing your art?
Bechdel: No, my mother was amazing in that way. I mean, that would have been a very easy thing to do and I think a lot of parents would have done that.

But my mother understood writing, understood the creative process, understood the imperative of, you know, creativity. And she was able to put those things in different compartments. I was going to tell the story. She would just live with it. It was not her story. It was my story.

Gross: My guests are Alison Bechdel, who wrote the graphic memoir *Fun Home*, and Jeanine Tesori and Lisa Kron, who wrote the songs for the Broadway musical adaptation. We'll talk more after the break. This is *Fresh Air*.

[soundbite of music]

Gross: This is *Fresh Air*. Let's get back to my interview with Alison Bechdel, who wrote the graphic memoir *Fun Home*, and Jeanine Tesori and Lisa Kron, who wrote the songs for the Broadway musical adaptation.

Alison, before you knew that you were a lesbian, you knew you didn't want to wear dresses and very feminine clothes. But your father wanted you to fit in and look like the perfect daughter from the perfect family, so he's make you wear clothes that you didn't really want to wear.
Bechdel: Yes.

Gross: How did it feel to wear clothes that didn't fit your sense of who you were when you were a child and didn't have the power to just say, no, that's not me, I'm not going to wear it?
Bechdel: You know, that struggle was so—came so early in my life. It's like one of the first things I remember is wanting to wear boys' clothes and fighting with my dad about it. And, you know, sometimes I would win [laughter], which testifies to the strength of that feeling in me. But mostly, when I did have to knuckle-under and dress up for a party or something, it just felt terrible. It just felt very powerless. I felt like I was living some kind of lie. It was not pleasant.

Gross: In *Fun Home*, you write about the first time you saw a butch lesbian. It was at a diner. You were there with your father. Would you describe that experience for us?
Bechdel: Yeah, this is one of my earliest memories. I think I must have been four—no more than four when this happened. I was traveling with my dad, probably to pick up a body for the funeral home. And we were in Philadelphia, like a large city, a much larger city than where we lived. And we were having lunch in this diner and this woman came in, the big burly woman with short hair and men's clothes. And I was spellbound. I was—my jaw dropped. And

my father saw me looking at this woman and he whipped his head around and said, is that how you want to look? And, you know, there was so much going on in that exchange. Like, in that moment, I recognized that woman. I identified with her. I wanted her. I wanted to be her. And I knew that that was completely unacceptable. My father didn't, you know—he just exploded that.

Gross: So there's a great song in the show *Fun Home* that describes this experience from the nine-year-old Alison's point of view. And this is—for anyone who saw the Tony Awards, this is the song from *Fun Home* that was performed on the Tony's. And before we hear the song, Jeanine Tesori and Lisa Kron, I want to talk about writing this song. The song is called "Ring of Keys," and, you know, in the drawing in the book *Fun Home*, you know, we see this, like, large woman with short hair and jeans and a plaid shirt and work boots on, you know, very much wearing clothes you might identify with a man, though a lot of women now—a lot of women wear those clothes, too. But anyways, there's something very mannish about her. But she does have this ring of keys hanging from her belt. And it's not a detail that's especially called attention to in the drawing. But that's the focus of attention in the song. Why did you make the ring of keys the symbol of everything that the nine-year-old Alison is feeling as she sees a butch lesbian for the first time?

Jeanine Tesori: Well, I think both of us—I think, Lisa—when we were talking about it, I remembered thinking, to a kid who is in school, that keys—and especially a lot of keys—to me meant access. I didn't know that word probably when I was that young, but I knew that those people—that those keys opened a lot of doors, which meant that there are a lot of places that they were going to, even if it was in one building, that that meant some kind of power. And I think, as an object, they're fascinating things, and you see babies playing with rings of keys. And the fact that she would have that on, that detail in it, I think it was one of those objects that I knew that Lisa and I were talking about is, what is—what would be the event? And the way that it built to—it's, like, the greatest thing ever. It just felt both childish without being childish. And that distinction is so important when writing from a kid's point of view.

Lisa Kron: From the very first moment that I thought about adapting this book, what I was really worried about doing well was portraying butchness and portraying exactly what is meant by that and what is felt in that because in mainstream culture, the way that it has often been expressed is as a stock character of ridicule. And I was very worried about how we would put this story and that character, and specifically that moment, on stage without triggering that ridicule and that sort of reflexive response. And so Jeanine said we need

to write a song about this panel and I said, we can't because there's not going to be a way to do it that people won't laugh at that character and I couldn't bear it. And Jeanine said, you know, we have to and then I said, okay, because I do what Jeanine tells me, so . . .

Gross: Well, let's hear the song. And this is "Ring of Keys," and it's sung from the perspective of the nine-year-old Alison Bechdel in the musical adaptation of Alison's graphic memoir *Fun Home*. And the words and music are by my guests, Jeanine Tesori and Lisa Kron. Alison Bechdel is with us as well. So here is the song and it's sung by Sydney Lucas.

[soundbite of song, "Ring of Keys"]

Lucas: (As Small Alison, singing) Someone just came in the door, like no one I ever saw before. I feel—I feel—I don't know where you came from. . . .

[back to interview]

Gross: That's Sydney Lucas singing "Ring of Keys" from the cast recording of the musical *Fun Home*. The music is by my guests Jeanine Tesori and Lisa Kron, and the story is based on the graphic memoir by my guest, Alison Bechdel.

Alison, were you concerned in the same way that Lisa Kron was concerned that a song about this moment, where the young version of you sees this woman and recognizes her and feels something, that if it wasn't handled really carefully that it would be offensive and taken as ridicule?
Bechdel: Well, I didn't know that they were working on that song. That all came as a surprise to me. Lisa and I had had many conversations before that, like, early in the process about the whole problem of this butch character, about making her, you know, positive and appealing to an audience because we just don't see butch women portrayed as appealing characters. But this is the great power of allies and the power of Jeanine as a straight woman, just barging in there and saying we got to do it. She could see that it had to happen.
Tesori: It's what straight women do, Alison, barge right in. [laughter]
Bechdel: And we're glad you do.

Gross: And I should mention that Lisa Kron is a lesbian. And, Lisa, do you think you were especially sensitive about this 'cause you know butch women and you were trying to see how they would respond to the song too and want to make sure that they would not feel personally offended by lyrics of the song?

Kron: Yes, the butch women and their femme girlfriends. [laughter]

Tesori: Well, look, I was at a play with Lisa, and there was a character who came on in a typical way. And I turned to the side to just see what was happening with her 'cause as I got to know her—and she's a sister to me now—and she was crying. And I thought, this—that's what she's talking about. You know, we had been discussing it, but to really sit next to it, I thought, oh I get it now. You know, so I can bring a kind of dramatic entitlement, but I saw—it destroyed her, and it was like, oh, there it is again. There it is. And it was all it took for her to stay in her seat.

Gross: My guests are Jeanine Tesori and Lisa Kron, who wrote the songs for the Tony Award–winning musical *Fun Home*, and Alison Bechdel, who wrote the memoir it's based on. We'll talk more and hear more music from the show after a break. This is *Fresh Air*.

[soundbite of music]

Gross: This is *Fresh Air*. And if you're just joining us, we're talking about *Fun Home*, the book and the musical. The musical won the Tony this year for best musical. My guests, Jeanine Tesori and Lisa Kron, wrote the songs. Lisa also wrote the book for the musical. The musical is based on a memoir told in comic book form by my third guest, Alison Bechdel. The story in the book and the musical is about Alison growing up and, after she came out at the age of nineteen, finding out her father, who was still married to her mother, was actually gay himself and her mother knew that, but the marriage stayed together.

Alison, you came out when you were in college—out-of-town school. And you write in the book, *Fun Home*, that until you came out and had an actual relationship with another woman that your homosexuality was theoretical, an untested hypothesis. [laughter]

Bechdel: Yeah.

Gross: Go ahead.

Bechdel: I came out by reading books, not by having actual experiences with other people. I had this very formative moment. I was browsing in my college bookstore, and I found this book called *Word Is Out*. It was a book about a documentary film that had been made which was interviews with a whole bunch of gay men and lesbians. I think it was made in the late seventies. And I was spellbound by this book. And as I was reading it, I had the simultaneous

realization that, oh, my God, I am one of these people in this book. And also that it was okay. Like, just like that, I accepted that in myself. I didn't have any long period of struggle. I had this great opportunity because of the moment. You know, the generational moment when I came out, it was okay to be gay in 1980.

Gross: Was there a part of your mind where you were thinking, okay, what if I make love to another woman and it turns out I'm not gay and I don't like the experience, then what? Did you have any doubts like that?

Bechdel: Well, [laughter] I read a lot more books after that first book. And I was getting a pretty clear sense that it was going to work out and be okay, but of course I didn't know that. I hadn't had sex with anyone at that point. So, yeah, it was still kind of up in the air for me until I actually did it. It was actually very awkward the first time, but I still knew it was okay.

Gross: So the song that's sung about Alison's first time making love to a girl is called "Changing My Major." And so the lyric is, I'm changing my major to Joan. It's kind of like a comic number, you know, and it's just filled with her just kind of exhilaration and your dizziness from this experience. Jeanine Tesori, Lisa Kron, why did you make this a more comic number?

Kron: The book is drenched in this kind of heartbreaking, elegiac tone. And we had to excise that from what we were writing because moving forward, the adult Alison knows that her father is going to kill himself. But the characters— the Small Alison and the college-age Alison—moving forward—her brothers, her mother—they don't know what's going to happen. And Alison had given us her work journal from when she was writing *Fun Home*. And in that work journal, she had copied sections of her actual college journal. And, you know, we could really see that in action that she didn't know what was going to happen. And all of a sudden, we realized that before you know what happens to her in the story is that she comes out. Four months later, her father kills himself. And so her coming out becomes, in retrospect, bound with that tragedy. But moving forward, she didn't know what was going to happen.

And so in that moment that she has sex for the first time, it's an incredible feeling of opening out. In the moment where she's first coming out, she's not thinking about her parents. Her world is opening up. And we realized that dramatically, it was going to be so powerful to have opening happen and to have that kind of lightness. And then there's this—you know, she's never dated. She's never experimented sexually. She's never—you know, 'cause she's a lesbian. So there was no way to do that. So all of this passion, this sort of

backlog of passion, is just going to shoot out at this person in this moment in a way that is just comedy gold, as they say.

Gross: Jeanine, this is a waltz. Why did you want to write this song in three-quarter time?

Tesori: Well, I like the idea of dramatically putting something which, you know, there was all this language that Lisa wrote, and it was really jumbly. And I think in those moments, it's the search for like [unintelligible]. And then ultimately, it's such a romantic, beautiful moment. It's truly—they're doing a dance, and she's jumbled, and then she's finding something. And there's this wonderful moment that Lisa wrote of—and it's very strange to be talking while I know that Alison is listening because we're talking about Alison's life—but I just imagined it to be this moment when she said, "I was—I really thought I would be alone for the rest of my life." And that's real. And then suddenly, there is this peace that comes with knowing that that's just not true. And I think there's nothing more beautiful or calming than a waltz like that. It's so romantic.

Gross: So here's the song. It's called "Changing My Major," written by my guests, Jeanine Tesori and Lisa Kron. And it's from *Fun Home*, which is based on the memoir *Fun Home* by my guest, Alison Bechdel. Singing "Changing My Major" we'll hear Emily Skeggs from the cast recording of *Fun Home*.

[soundbite of song, "Changing My Major"]

Gross: That's Emily Skeggs singing "Changing My Major" from the cast recording of *Fun Home*. It's the musical that won the Tony Award for best musical this year. Let's take a break, then we'll talk some more. I have three guests—Alison Bechdel is the author of the graphic memoir *Fun Home*, and Lisa Kron and Jeanine Tesori wrote the songs for the musical *Fun Home*, which won the Tony this year for best musical. We'll be back after a break.

[soundbite of music]

Gross: This is *Fresh Air*. Let's get back to my interview with Alison Bechdel, who wrote the graphic memoir *Fun Home*, and Jeanine Tesori and Lisa Kron, who wrote the songs for the Broadway musical adaptation.

Alison, after you came out, you went home to your parents' home and you wanted to talk with your father because at this point your mother had written

Panel from *Fun Home* that inspired "Ring of Keys" in the musical version of *Fun Home*

you the letter saying that your father was gay. So you went there to talk with him. Judging from the musical and your memoir, it didn't go very well, that he was not prepared to have that conversation.

Bechdel: Yeah. I knew that I wanted to establish contact with him. I wanted to have us both acknowledge this to each other. It had been all, you know, through letters and through my mother talking behind his back to me. But I wanted to have a direct conversation with him, and I was terrified to broach it. I didn't know how it was going to happen. We finally—at the end of this week, we finally ended up in the car together going off to a movie. And I was doing that thing where you see a sign. Like, I was—when a streetlight changed, I was going to say something, so that's how I forced myself to finally broach the topic with my dad. And he was very shameful. It was like—it was as if we had suddenly had this parent-child role reversal. He became very sheepish and also very confessional. He started talking to me about being a little kid and wanting to wear girls' clothes and about his first experience with another boy when he was fourteen. And it was kind of overwhelming, you know, and I wanted to talk about me too, and there just wasn't room for that. He was so filled with pain and shame that it just was all about him.

Gross: So this is another song in the musical *Fun Home* in which Alison and her father are in the car having the kind of conversation that she's just described. That's a difficult one to make into a song. Jeanine, Lisa, do you want to describe that process?

Tesori: You know, I write musicals for a living. And after a while, where the sweet spot is for a song just pops out whether or not you get to write it. And this was very, very obvious that this had to be musicalized. But song form AAB, it couldn't be because it didn't have a form. I always think that—and Lisa and I talked about this endlessly—that form and structure were always fighting in this musical because they were characters who couldn't find a way to sing and children who were trying to sing the song of the parents who didn't have the form and structure to sing.

And so they are both searching and the accompaniment has a row going [imitating song structure]—and then there's the waiting and the repetition of "I'll do it here, I'll do it when we get there, I'll do it when we get here." And then the hesitation from the parent to the child and then the child who sees an opening and it's just not a song form.

And it's very hard for me to go see the musical now because I'm not noting it and my head isn't inside—oh, that's out of tune, and I find this particular section unbearable because of my own relationship with my father who's not alive. You know, the things that were left unsaid and the silence just—the presence of that silence in my life is—makes it—I literally just shut my eyes when this goes by because there's so many things. It would have been easier had certain things been said, and it's too late now. And watching the attempt and the incompleteness of the moment is—I find it really wrenching to watch. It's almost like I didn't write it with Lisa. It goes into another space for me.

Gross: Lisa, is it as emotional a song for you as it is for Jeanine?

Kron: I don't think in the same way. It's one of my favorites, I have to say. And it was clear to me at some point, you know, I read Alison's book many, many, many times. And we were inside of it for six-and-a-half years. It took me a while, but at some point I saw that it's a two-page series of panels—that car ride. And reading straight through it one time, when I'd been working for the book for a long time, I realized that there's this sort of increased tempo going to that moment. And then this horrible stillness after it. And I'm talking about inside the book. It's the emotional climax of the book.

And so I think then we knew that there was some way that that had to be true in the play. And one of the things that happens is that that car ride is taken with Alison in college. And there's a moment right before where the

character of her dad is talking to the college-aged Alison as our adult Alison looks on as she's doing as we're sort of moving all those three time periods simultaneously. And then the character of Bruce just sort of—with not too much fanfare around it, thanks to our subtle director Sam Gold—turns to the adult Alison and says, are you ready for that car ride? So the person who sings it is the adult Alison.

Bechdel: This is Alison coming in. I just wanted to say that when I first saw that moment on stage in an early workshop version of Bruce turning to not college-age Alison, but the adult Alison—that was so emotional. I totally teared up and I don't—I'm not a crying person, but that was really powerful that the adult Alison and the father finally were connecting on stage before me.

Gross: Which you didn't get to do in real life.
Bechdel: Yes.

Gross: So let's hear the song that's called "Telephone Wire." And singing we'll hear Beth Malone and Michael Cerveris from the cast recording of *Fun Home*.

[soundbite of song, "Telephone Wire"]

Gross: That was Beth Malone and Michael Cerveris from the cast recording of *Fun Home*. With me are the songwriters of *Fun Home*, Jeanine Tesori and Lisa Kron. Lisa also wrote the book for the musical. And also joining us is Alison Bechdel, and her graphic memoir *Fun Home* was adapted into the musical. Alison, let me get back to you. After you came out, your mother filed for divorce. Do you think her filing for divorce was related in any way to your coming out?

Bechdel: Well, I do. I feel like this whole sequence of events was somehow my fault, even though I might know intellectually it's not. I—it's very hard for me even now to separate them. But I feel like if I hadn't come along blithely announcing that I was a lesbian, my parents would've gone on the way they have been in this difficult, secretive, repressed situation. But no one would've jumped in front of a truck. No one would've gotten divorced. So I feel like I precipitated all that. I don't—you know, I wouldn't change it. I don't think it was my fault, but somehow I can't see it outside of that sequence of events.

Gross: Your father was hit by a truck and you believe it was suicide. What leads you to that conclusion?

Bechdel: Well, that my mother had asked for a divorce, that my father had been behaving so erratically. My mother would call me upset. He's just thrown a painting down the stairs. And so something—in some way, he started to—I don't know—compensate. Like, there was something he was just having a very hard time managing. And so there are other little clues I would find. He was reading a book by Camus called *A Happy Death*, underlining certain passages about love and not being able to love. It just seemed like his life had become impossible.

Gross: My guests are Alison Bechdel, who wrote the graphic novel *Fun Home*, and Jeanine Tesori and Lisa Kron, who wrote the songs for the Broadway musical adaptation. We'll talk more after the break. This is *Fresh Air*.

[soundbite of music]

Gross: This is *Fresh Air*. Let's get back to my interview with Alison Bechdel, who wrote the graphic memoir *Fun Home*, and Jeanine Tesori and Lisa Kron, who wrote the songs for the Tony Award–winning Broadway musical adaptation. When we left off, Alison was explaining why she thinks her father's death was a suicide.

Your family had a funeral home. Was that where your father's body was?

Bechdel: Yeah, that was another really disturbing thing about my father's death, was that he was laid out in our family funeral home, where I had seen many—you know, my brothers and I would play in the funeral home when I was growing up. We'd see these old people, all embalmed in the caskets, and we just thought it was such a crazy ritual. And then all of the sudden, here's my father, embalmed in a casket in our funeral home. You might think that being raised around that, all that, you know, everyday kind of experience of death would prepare you better for it, but I feel like it made it more surreal for me.

Gross: I'm thinking that maybe the first man you saw naked was a corpse?

Bechdel: Yeah, that's true. Yeah, when I was around ten or so, once, my dad called me back into the embalming room. And I don't know why, I don't know what was going on. He had some little thing. He wanted me to hand him the scissors or something. But lying on the table was this naked man—not an old man. Like, most of the people my father dealt with were elderly. This was a young guy—big, muscular guy—stark-naked and with his chest cut open, I guess from an autopsy or something. It was really—you know, it was very traumatic to see that.

Gross: I can imagine it would be traumatic to see that. What effect do think that had on you?

Bechdel: [Laughter] I can almost feel the way that my whole system just shut down in that moment because I knew I couldn't betray that I was upset. I couldn't show emotion at all. If I had freaked out, my father would have been contemptuous probably, so I just—I knew that this was—I just had to suck it up.

Gross: Alison, listeners will be really angry with me if I don't ask you about the Bechdel test. And why don't you describe what it is?

Bechdel: [Laughter] All right, well, I feel a little bit sheepish about the whole thing because it's not like I invented this test or said this is the Bechdel Test. It somehow has gotten attributed to me over the years. Many, many years, ago back in 1985, I wrote an episode of my comic strip where two women are talking to each other about—they want to go see a movie. And one woman says, you know, I'll only go to a movie if it satisfies three criteria. I have to confess that I stole this whole thing from a friend of mine at the time because I didn't have an idea for my strip—my friend, Liz Wallace. And Liz said, okay, I'll only see a movie if it has at least two women in it, who talk to each other about something besides a man. And that left very, very few movies in 1985. The only movie my friend could go see was *Alien* because two women talked to each other about the monster. [laughter]

But somehow, young, feminist film students found this old cartoon and sort of resurrected it in the internet era. And now it's this weird thing. Like, people actually use it to analyze films to see whether or not they pass that test.

Gross: So . . .

Bechdel: And still, very few—surprisingly few films actually pass it, although more and more do.

Gross: Since the idea of this criteria was suggested by your friend whose last name is Wallace, would you like it to be renamed the Bechdel-Wallace test?

Bechdel: I would be very happy if that happened.

Gross: [Laughter] So one more song I have to ask you about, and this is a total change of mood. There's a song that's, I think, a parody of *The Partridge Family* theme. And it takes place in actually a dark moment of the show, as I recall. The fantasy song is called "Raincoat of Love." So did *The Partridge Family*—am I right in thinking it's *The Partridge Family*?

Tesori: Yes. Oh, yes.

Kron: Absolutely. One of my proudest moments was when my agent asked me if we had rights to it. [laughter]

Gross: Very good. So, Alison, did you go through a kind of "I wish" type of fantasy of ever wishing, like, your family was like the Partridge family?

Bechdel: Yeah, except for me it was more *The Brady Bunch*. I totally, totally wanted to live like *The Brady Bunch*.

Gross: Okay, so we're going to end with this kind of fake happy song . . . [laughter] . . . called "Raincoat of Love." And is—could you have come up with, like, a cornier phrase—a raincoat of love to protect you from the world? [laughter]

Tesori: Lisa Kron, ladies and gentlemen.

Kron: There were strangely the hardest lyrics to write.

Gross: Because they were so not you?

Kron: No, because they were so—they're so—they have to be bland and yet not, you know?

Tesori: And everything is with an apostrophe—"sneakin'."

Kron: That's right.

Tesori: "Sneakin'."

Kron: We really enjoyed that. We liked, like, parenthetical titles, yeah.

Tesori: "Singin'."

Kron: When we listened to a lot of those songs, we realized many of them had to do—in the seventies—those pop songs—just sneakin' around.

Tesori: Right.

Kron: Yeah.

Tesori: A lot of minor chords.

Kron: Yeah.

Tesori: [Imitating chords]

Kron: Right.

Tesori: [Singing] I can feel your heartbeat.

Gross: [laughter]

Tesori: You're welcome. That was for you, Alison. [laughter]

Gross: I want to thank the three of you so much. It's really been great to talk with you. Alison Bechdel, Lisa Kron, Jeanine Tesori, thank you all so much. It's really been a pleasure.

Bechdel: Thank you, Terry.
Kron: Thank you.
Tesori: Thank you.

[soundbite of song "Raincoat of Love"]

Unidentified Actors: [As characters, singing] Everything's all right, babe . . .
Perez: [As Roy, singing] . . . When we're together.
Unidentified Actors: [As characters, singing] When we're together. 'Cause you are like a raincoat . . .
Perez: [As Roy, singing] . . . Made out of love.

[back to interview]

Gross: My guests were Alison Bechdel, who wrote the graphic memoir *Fun Home*, and Lisa Kron and Jeanine Tesori, who wrote the songs for the Broadway adaptation, which won this year's Tony for best musical.

Stuck in Vermont—Alison Bechdel's *Fun Home* on Broadway

EVA SOLLBERGER / 2015

From *Seven Days Magazine*, April 17, 2015. Reprinted with permission.

Vermont cartoonist Alison Bechdel published her graphic novel *Fun Home* in 2006. The best-selling book told the tale of the author's tumultuous childhood in rural Pennsylvania and the complex events that led to the tragic death of her closeted father.

In 2013, a musical adaptation of *Fun Home* was mounted at the Public Theater in New York with book and lyrics from Lisa Kron and music by Jeanine Tesori. In March, *Fun Home* moved to Circle in the Square Theatre and opened to rave reviews on April 19.

The musical depicts three versions of Alison (small, middle, and forty-three years old) and jumps frenetically through time, slowly unfolding her emotionally charged tale. Playing the role of Alison's little brother is eleven-year-old Vermonter Oscar Williams. Oscar got "Stuck in Vermont" in November of 2014 when he shared his dream of performing on Broadway—which has now come true.

Eva and *Seven Days'* cofounder Pamela Polston got temporarily unstuck from Vermont to see the show and meet up with Alison on Broadway.

Cuts to **Bechdel**: I feel like I'm going through some kind of transition.

Sollberger: Like a butterfly?
Bechdel: Yes. Do I look like a butterfly?

Sollberger: You look like a butterfly in a very nice suit. [Bechdel and Sollberger laugh.] Welcome to "Stuck in Vermont," brought to you by *Seven Days*.

My name is Eva Sollberger, and we are not stuck in Vermont anymore. That's right; we are on Broadway in New York City. Tonight at the Circle in the Square Theatre, we are going to see *Fun Home*, a musical that was adapted from the graphic novel by Vermont cartoonist Alison Bechdel.

Sollberger: What's it like as T-RAB?

Bechdel: I love being T-RAB. T-RAB is The Real Alison Bechdel and a couple of times we've done publicity events where I actually participate with the actors. They'd all have their names and my name would be "The Real Alison Bechdel." It was fun to feel like I was part of the show.

Sollberger: You are a part of the show.

Bechdel: Well, it's funny because I'm not in some ways. It's not mine. I didn't write it. I had nothing to do with the creative process behind it. But it's my material. It's my life.

[excerpts of the interview not regarding Alison Bechdel removed by interviewer]

FUN HOME THE BOOK

Bechdel: Well, it actually gestated for twenty-seven years but it took me seven years to actually write and draw it, but it was a story I wanted to tell for a long time and just couldn't for various reasons. But finally I felt like I had to. I'm not a super share-y type, but I do have this weird exhibitionistic streak, Catholic streak, where I feel like I have to confess. I loved confession as a child. If I tell this whole story as accurately as I can, I'll feel some kind of grace. And bizarrely, I have.

FUN HOME ON BROADWAY

Bechdel: I didn't know anything about musicals really going into this, but it's really emotional form. And the way the playwright and the composer worked together they found all the emotions, all the key emotional points of the story, in a very surgical, direct way that I didn't really do. I was bumbling around, trying to figure it out.

Sollberger: Caption: in 2008, I interviewed Alison for a "Stuck in Vermont" at her home in Bolton.

Cuts to **Bechdel** in 2008 interview: My father was gay and I was, and we both grew up in this same little Pennsylvania town. He killed himself, and I became a lesbian cartoonist.

Cuts back to **Sollberger:** If you've seen *Fun Home* the musical, you probably recognize this line. It didn't come from the graphic novel. It came from Alison in this [2008] interview. This is just one example of how blurred the line is.
Cuts back to **Bechdel:** That's been the amazing thing: the tremendous respect for the fact that this is a true story about real people. There would be no story if my father hadn't died. And it's not like it's a happy story. It's not like something you would celebrate or be proud of. I know my parents would be very excited somehow, if you could set aside the content of the story. They would be ecstatic. My father to see his wallpaper on a Broadway stage would be in heaven.

[Audio of piano music]

Sollberger: Is that your mom playing?
Bechdel: Yeah. We have exact editions of books I mention. Not just a copy of *Ulysses*, but the exact one I had.

Sollberger: How do your brothers feel about all of this?
Bechdel: They're psyched about it. The book, I feel like, is exactly replicated in the play. But even the stuff they completely make up, like the *Partridge Family* number, feels somehow accurate. Somehow almost like, oh yeah, that happened in my childhood; we danced that *Partridge Family* number. [Laughs]
 One really great song is called "Telephone Wire." It's based on a line in the book, "At the light." I'm trying to psych myself up to broach the topic of homosexuality with my dad, because I know that he's gay. He knows I know, but we haven't actually talked about it yet. I'm trying to make that conversation happen. Like the "Ring of Keys," those words aren't even in the books, but they based this whole song on this tiny little image.
 I guess the older I get, the more distance I get from the person I was when I wrote that book, the more I realize it really was just my version. I really thought when I set out that I was getting to the truth of my family. There really is no one truth. There are a lot of stories afoot in my family.

Cuts back to **Sollberger:** Alison drew the comic *Dykes to Watch Out For* for twenty-five years.

Bechdel: Five hundred and twenty-seven episodes. My comics ran in *Seven Days* for many, many years. The internet was changing everything for cartoonists whether you were gay or not. And I was making less and less money and I was getting older and needing more and more money and it was getting pretty grim. So I've been really lucky. I was so lucky that *Fun Home* had the success that it did.

Sollberger: What kept you going forward?
Bechdel: I love trying to tell stories. I love trying to make sense out of real life in comics.

Cuts away to **Sollberger**: In 2014, Alison was awarded a MacArthur Fellowship. And perhaps you've heard of "The Bechdel Test." Well, that originates in one of Alison's *Dykes to Watch Out For* comics.

So how's this outsider, lesbian cartoonist deal with success?

THE FAME MONSTER

Bechdel: Yeah, little did I know how much less underground I was going to become. But I still feel kind of that same way. I haven't caught up with myself. I have not been doing a lot of my own works. I've been travelling and yacking. I'm so sick of talking about myself. I can't even tell you.

Sollberger: You know what you should do?
Bechdel: What?

Sollberger: You should have one of the Alisons do all your press for you.
Bechdel: [laughs] It's giving me more endurance. I think when all this hubbub dies down, I'll be able to do more good work. I hope.

HAPPILY STUCK IN VERMONT

Sollberger: Why do you live in Vermont?
Bechdel: Because I love Vermont. I just love it. I've been there over twenty years now. I love being in the country. I love the mountains. I love being able to bike and ski. There's not that many places. There's more now, but twenty years ago there weren't that many progressive *and* rural places that you could live and feel safe, certainly as a lesbian. You know, you can eat so well there. Almost everything is local. You know everybody. I just love Vermont.

Sollberger: It's not just Alison and Oscar who get to enjoy this moment on Broadway. Since *Fun Home* previews opened in March, Vermonters have been flocking to see the show.

Bechdel: Yeah, there's been this strange sort of feedback effect from seeing these people make this beautiful artifact of my story. I don't usually speak in religious terms, but it does feel like grace or a blessing of some kind, a great gift.

Alison Bechdel, Onstage and on Recode Decode

KARA SWISHER / 2017

From *Recode*, February 8, 2017. Reprinted with permission.

Kara Swisher: Today in the red chair is Alison Bechdel, the award-winning cartoonist behind *Dykes to Watch Out For* and the graphic novel *Fun Home*. I interviewed Alison onstage at the Curran Theater in San Francisco, which recently underwent a big renovation. We spoke in front of a live audience immediately after the performance of *Fun Home*, which was adapted into a Tony Award–winning musical. Let's take a listen.

Hey everybody. I kind of look like Alison Bechdel, too. All lesbians look like this. There's a little Rachel Maddow going on, and stuff like that.

If everyone could sit down, we're going to start. My name is Kara Swisher. I'm a journalist. I typically write about tech, I do tons and tons of interviews with all the big tech titans. But this afternoon, I am so thrilled to be interviewing Alison Bechdel, who saved my life with *Dykes to Watch Out For*.

This is a bucket-list interview, as far as I'm concerned. Even better than Kim Kardashian, which was quite enjoyable, I will tell you. She's very smart, very sly. Anyway, without further ado, I'm gonna bring Alison out here, and then I'm gonna interview her a little bit, and then we're gonna take questions from the audience, which is great.

Alison Bechdel. Let's give her another round of applause. What an astonishing piece of art that you've created. And by the way, the cast, I know they're back there, let's give them [a round of applause]. That was astonishing. So, Alison. That was intense, okay?

Alison Bechdel: It is, isn't it? I know.

KS: So talk a little bit about the play now. 'Cause it's been going on, you wrote the book ten years ago, almost, is that correct?

AB: Yeah, that book came out, actually eleven years ago.

KS: This was the illustrated novel, right?
AB: Yeah.

KS: Which hit huge, got all kind of accolades. Talk about the journey about this play and then we're gonna get into things like politics, and other, and art. We have to, I'm sorry. #MuslimBan, we cannot not discuss it.

So let's start with [the play]. How do you feel about the journey of this? 'Cause it still feels fresh and pertinent and meaningful, on lots of levels.
AB: Yeah, it was a very long journey from . . . well, the book itself was a long journey. Took me like seven years to write it. And I didn't even begin it until I was almost forty, as you saw, in the story. It took a long time. It was sort of torturous watching the character who plays me going through her creative suffering, 'cause that's just how I work. I still go through that every day.

So then, after the book came out, very early on, there was this offer to turn it into a musical. Lisa Kron was attached to this project of wanting to turn my book into a musical, which I thought was really . . .

KS: Did you say that [at the time]? Because someone, who, as a friend, I brought with me—I brought all straight people and a gay—and she said when they read the book, the gay didn't believe it was gonna be a musical.
AB: No, I thought it was nuts. I couldn't imagine how it would become a musical. But I didn't know much about musicals then. You know, I was just thinking of, like, *Guys and Dolls* or something. Couldn't quite picture that.

KS: Can you imagine *Guys and Dolls* version of this? It would be tasteless. It would be tasteless.
AB: But I said yes to it, because I knew Lisa, and trusted her. Also, it felt so alien, like such a different form, that I could let go of it. I didn't have any involvement. I turned over all my creative rights to this team. And then, time went by. Years went by. And I didn't hear anything about it, and I started to wonder, is this really happening?

But maybe four years later, they did a workshop, and I got a tape—well, a CD—of the actors performing these songs. And it was . . . It just staggered me. I didn't know what I had been expecting, you know? I knew they were doing this. But when I actually heard it, it was so powerful.

KS: Did you have any hand in writing any of the lyrics?
AB: Zero.

KS: Zero. So they just took your work, which was an illustrated novel, and then made it into this.
AB: Yes.

KS: Was it hard letting go of the artistic pride that you created this? Did you have suggestions or differences?
AB: I got to see these early workshops and things, and give them feedback, which they were very kind about listening to. And [they] took some of it, I think. The thing is, the whole team—Lisa Kron, the writer, Jeanine Tesori, the composer, and Sam Gold, who directed it—were kind of amazing in the way that they respected the fact that this was about my real family.

KS: Right.
AB: Obviously, they took lots of liberties. They made stuff up. My family didn't really dance around like the Partridge family.

KS: That is a great disappointment to me, 'cause . . . Wait, one question. The "Fun Home" ad? You had to have, please, for the love of God, done that?
AB: No.

KS: Oh.
AB: I mean, we did make commercials for stuff, with our cassette recorder.

KS: Cassette tape, yeah.
AB: But no, Lisa wrote that.

KS: Okay.
AB: It's so perfect.

KS: Yeah. So you wish you had.
AB: I wish I had, yeah.

KS: So, when you see it now . . . Like, you were in the audience. I don't know if you realized, she was sitting in the audience. How does it feel to watch this? Because it is, you know, it's completely about you, and your life, and a very difficult relationship with your father, a complicated relationship.
AB: Well, I dissociate a little bit. You know? The first time I saw it, it was so powerful. And, I don't know, it's like seeing an amazing view: The first time you see it, you can't believe it, and you just have this physical, visceral

reaction. But after, then you get used to it. So, it's very sad, but I've kind of gotten used to it. It's like listening to an amazing song over and over until you can't really hear it. So, that's not a very exciting answer, I'm sorry, but it's the truth.

KS: She was completely sleeping, I think is what she just said, during this. No.
 Now you have another book, *Are You My Mother?*, which was another illustrated novel. Just sort of a sequel to this, or . . . ?
AB: It is, kinda. It was not intended to be. But it turned out that way. It's a memoir about my mother, and also, in an odd way, a memoir about the process of writing *Fun Home* and navigating that with my mother, who was none too keen on it.

KS: How does she feel now? Because by the way, that song of hers in this musical, I think, is probably my favorite.
AB: Yeah, that song's amazing.

KS: It's a heart-wrenching song.
AB: And that's something that . . . My mother hardly appears at all in the book *Fun Home*, because I was so terrified, I knew she was gonna be reading it, so I tried to keep her out of it as much as I could.

KS: I know that feeling. My mom is here.
AB: What?

KS: She's fantastic.
AB: Oh.

KS: All the time.
AB: Okay.

KS: We won't go into the coming-out story because she doesn't come out well in that one.
AB: Oh, no.

KS: The original one. She's great now, she's great now. It's a redemption story. Anyway, so how does your mother react now, how does she feel about this?
AB: Well, this is the sort of sad, but in some ways not, thing. My mother did not ever see the play. She died the year that it opened off-Broadway. And she

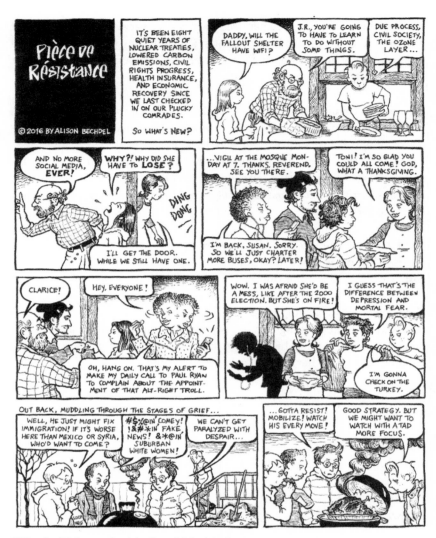

"Pièce De Résistance," originally published in *Seven Days*, November 23, 2016

knew it was happening. She would say things to me like, "Well, I can't wait to see the reviews."

KS: Just that tone, right?

AB: Yeah, yeah. But it was . . . She . . . You know, I feel like if she had not died, seeing this play would've surely killed her, I think it would have.

I mean, I think it would have been very painful. Obviously, in some ways, but also, in another way, she didn't like being turned into a character in a book and she certainly . . . Well, she might've had mixed feelings about being turned into a character on the stage, because she was actually an actress. She did summer stock theater when I was growing up. So I think there was a way she might've actually been delighted by all of this.

KS: Sort of like, "I hate this, and yet, I look really good."
AB: Yeah.

KS: "The actress plays me really well."
So, tell me what you're doing now. Because you brought *Dykes to Watch Out For* back, for a brief second. We were all hoping for another series of books. We just want you to write . . . If I have a billion dollars in the tech industry, as I should have, I would have just paid you just to write *Dykes to Watch Out For*.
AB: That would've been amazing.

KS: I know. I just . . . I would do that with a lot of people.
AB: Wow.

KS: Yeah. Why did you stop doing that, and then you started . . . You just did one panel, essentially.
AB: Well I stopped, just coincidentally, at the end of the Bush administration. Just before primaries, when it was Hillary and Obama.

KS: That's known as "good times" now, but go ahead.
AB: Oh, God. I know. "The good old days."

KS: I know.
AB: Those lovable scamps.

KS: The Bush boys.
AB: But I was . . . A) I was really ground down to a pulp by writing about the Bush administration. And B) I just couldn't keep doing it and do the other things I wanted to do. I'd been doing it, at that point, for twenty-five years, and I felt like it was—now I could—it was a good stopping point. I didn't intend to stop. I was gonna take a break. But then I just realized, yeah, I was done.
And people over the years would talk to me and say, "Oh, I miss your comic strip. What are the characters up to? What do they think of Obama?" And I

would have this, again, another disappointing response, which was, "I don't know. I have no idea." 'Cause I wasn't really thinking about them. I was very relieved to just be done.

KS: So, the creator has gone away.
AB: Kind of, yeah.

KS: Essentially, God has left the building. Wasn't interested anymore.
AB: But, after this election, I suddenly could hear and see them, and felt this tremendous need, for my own sanity, to bring them back, and try and write about what was happening in the moment. Because that's what I would use the comic strip for, myself, is to make sense of the chaotic world, and I never needed it more than last November.

And I wish I could keep doing it. I hope to keep doing a few more episodes, but it's incredibly time-consuming.

KS: Oh, sorry.

One of the things I wanted to talk about just a tiny bit, then we'll get to questions, is how you feel as an artist and being political. Because right now, it kind of demands it. And when you were doing it during the Bush administration, it demanded it. How do you look at your role, as an artist, now? Do you feel like you have to weigh in? Or do you want to do something else?
AB: Oh no, I want to weigh in. And I've gone off into these weirdly personal things since doing the comic strip, doing these family memoirs, and I'm working on another kind of memoir now. It does all start to seem a little . . .

KS: Your brothers? What?
AB: No. I used to say I was gonna write about my brothers, but think that's sort of not happening now.

KS: Okay.
AB: Maybe later.

KS: Why'd you just make a face?
AB: Oh, 'cause my family got kinda burned out on all of this, frankly.

KS: Yeah. Yeah.
AB: Yeah, it was a little hard on them.

KS: Yeah, my son is always like, "Stop writing about me, Mom. That's enough." But then I say, "Too bad. You were born into the wrong place." But, so what are you working on, right now?

AB: I'm working on a memoir about physical fitness and mortality. And it feels so frivolous, given what's happening around us.

KS: Explain that. Physical fitness and mortality? Like, "Don't exercise, what's the point?"

AB: Kind of. Yeah. I mean, I do exercise. It's something I've always loved. But I also feel like . . .

KS: Well, you're very fit.

AB: Thank you. Okay. But yeah, it's like, it's not gonna save me. I'm still gonna die. That's sort of hitting me.

KS: Yeah.

AB: Recently.

KS: Yeah. Although, you know, a lot of Silicon Valley billionaires are working on life-extension and death-avoidance schemes.

AB: That's crazy.

KS: Peter Thiel had this thing called "parabiosis," where you take the blood of young people. Not that he's doing it, allegedly. But there's all kinds of schemes going on now, in Silicon Valley, on those issues.

AB: Oh my God. It's a crazy time.

KS: Yeah. So it's a book, fitness and mortality, meaning you working out, and . . .

AB: I haven't quite figured it out yet, I'm still working on it.

KS: Do you have a title?

AB: Yes, it's called *The Secret to Superhuman Strength*.

KS: Oh, nice. Okay.

AB: That was a comic book ad I saw as a kid that sucked me in and I sent away for it. I really, really wanted "The Secret to Superhuman Strength." And it was this crazy manual for a weird martial art that I couldn't possibly understand.

KS: Yeah.

AB: It was very disappointing.

KS: All right. So you live in Vermont, correct?

AB: Yes.

KS: And what is your . . . I always ask this to everyone. I know it sounds crazy, whether you're Steve Jobs or Oprah, like, what do you do all day? What is your day in Vermont like? You're in Burlington?

AB: I live in the woods outside Burlington.

KS: Okay.

AB: I get up. I do some yoga. Try to do some seven-minute workout. And then I go sit in my office, on my computer. Writing this crazy book.

KS: Writing the book.

AB: Writing the book. And, sometimes, drawing the book.

KS: And it will be illustrated?

AB: Yeah, it's gonna be a cartoon. A comic.

KS: Yeah. And 'cause we're in San Francisco, are you particularly technical? You and I emailed back and forth and you said you're a bit of a geek, or—do you feel you are?

AB: I'm a bit of a geek. Certainly not as big of a geek as you.

KS: That is fair.

AB: But no, I started doing comics in the eighties. Like before there was anything digital. And I adopted stuff as it came along. I got a graphic tablet, and I got Photoshop, and I got a digital camera. The camera really transformed my work a lot. I used to make little, quick reference sketches for my drawings, or I'd look at myself in the mirror, or, if it was really complicated scene, I'd take a Polaroid, which was really expensive, it was like a dollar for every Polaroid you took. But once you could take digital photos, it was endless. You could take as many free pictures as you wanted. And I did that. For all the scenes in *Fun Home*, I posed for all the characters.

KS: Oh, wow.

AB: Yeah. It's a little obsessive.

KS: That's okay. I know a lot of people like that. So, do you use a lot of social media? I want to get into politics very briefly, and then we'll get questions from the audience. Do you use social media?

AB: No, I kind of got into blogging at the time that *Fun Home* came out and I suddenly had this big audience, it was really fun to make blog posts and have people reply. But then Facebook kind of put the kibosh on that.

KS: Yeah.

AB: Is that the second time I've said, "Put the kibosh on"?

KS: No, just once, and it's fantastic. If you say "skedaddle," I'll be thrilled. "Jeepers" would work, too.

But, you don't use . . . you don't use it as an artist, or for talking to your fans?

AB: No, I did. But I got really burned out on it.

KS: Because?

AB: Just because . . . You know, as a juggernaut of *Fun Home* kept going, I started to feel, finally, at last, overexposed, you know?

KS: Mm-hm.

AB: It took a while. I had to . . . But I reached my threshold. I was like, "I don't really need to be online talking to people all day about what I'm doing."

KS: Right.

AB: It was seductive for a while, though. I can see why people do it.

KS: It is. It's addictive. It's an addictive hellscape. All right, so before we finish, talk a little bit about politics, now.

AB: Oh, God.

KS: Because one of the things that you like about coming to San Francisco, these are "alternative facts," here in San Francisco, to what's happening. How do you look at the current political scene, and also the resistance to it?

AB: Well, I'm trying not to succumb to despair, and the resistance is really helping me to do that. I went to the March on Washington last week, and it was really . . . It was transformative. I've been to a lot of big marches and demonstrations, but I've never been in a crowd like that.

KS: Mm-hm.
AB: It was like . . .

KS: It was. I was there, too. It was astonishing.
AB: It's just being a particle on this giant organism that you didn't even know where it was going or what was happening. And there's something about just being there, with my body, with all these other bodies in that place, that felt like, this might really happen. We might be really getting our shit together, at long last.

KS: And how do you look at . . . But, at the same time, there's constant . . .
AB: Oh my God. Every day. It's like a kick in the stomach. I know. Yesterday morning was just abysmal. But then, by the end of the day, all these demonstrations at the airports.

KS: Right.
AB: All those lawyers coming out.

KS: Right. Right.
AB: Did you see, there was a really funny sign yesterday? It was, "First they came for the Muslims, and we said, 'Not today, motherfuckers'"?

KS: Did you like the signs at the Women's March? They were so good. You know, "We Shall Overcomb" was my favorite. And then, my very favorite was "Heil Twitler."
AB: I didn't see that.

KS: But yours is better.
AB: My favorite one from DC was this long quote from Hannah Arendt. It was like five hundred words on a placard and I can't tell you what it said, but it was really good.

But I do feel like part of my political responsibility right now is not to give in to despair.

KS: Mm-hm.
AB: It's really hard. But, here we all are together. There's so many people who are the good guys. And I feel very heartened by that. And I think—it's going to be, obviously, a long slog, but I think we're gonna do it.

KS: Does it remind you of . . . It just was reminding me the other day, because for some reason *Philadelphia* was on TV last night, and I watched it. I hadn't seen it since it came out, really. And it reminds me a little bit of that time. You remember that? I remember being on the Mall and doing the AIDS quilts, and stuff like that.

AB: Uh-huh.

KS: And I do remember the feeling of great despair, when that was all happening. People were dying.

AB: Yeah.

KS: It felt like that, and then, fast-forward, today.

AB: This feels like another order of magnitude.

KS: Yeah.

AB: But, certainly, the same thing.

KS: Last question: What are you doing, besides despair? Is there any action, as an artist or a person, [that] you think people should take? You don't have to give advice to people or anything like that, but I'm asking . . .

AB: I think for me . . . We have to do things that we're best at and the things that we love doing. I think just finding joy in the world is really politically important, if people are doing what they're happy doing. I don't mean slacking off and getting drunk, but really doing the thing that makes you feel alive and engaged. Like, that's what you should be doing, whatever it is.

KS: And also plotting the Free Melania.

So let's have questions from the audience. We have time for just a few. Don't be shy. You have Alison Bechdel here, so ask a question of her.

AB: I'm here.

Audience 1: Hello.

AB: Hello. It's me.

Audience 1: That was amazing, thank you for writing that. Do you know how they went about finding the actors and actresses?

AB: Do I know how they went about finding them? I don't. Would've been fun to sit in on the casting, though. I do know the story of Kate Shindle—who you

didn't see today, because her understudy played my character today. But Kate Shindle, who was a former Miss America, she normally plays Alison in this production And she got the part 'cause she came to see the show on Broadway and just really was excited by it, and said, "I want to do this." And then she tried out, and she's doing it. But I don't really know how the theater stuff works. In high school, I was on the stage crew. I didn't hang out with the actor kids. There were too cool.

KS: Yeah, yeah. What did you do in high school?
AB: I took my dad's English class.

KS: My favorite part of this was you going to the Gay Union and going "Danke." I did that, I think. Another question?

Audience 2: Hi, I'm here. My friend's daughter played you and was nominated for a Tony. Emily Skeggs.
AB: Oh, wow.

Audience 2: So I just sent her a text to ask her how Emily got the role, 'cause I don't know, so when I find out, I'll let you know.
AB: Okay.

KS: All right, next?
AB: Emily was great.

Audience 3: Hi. I was wondering what your updated views are, kind of how the Bechdel Test has changed, especially with the push for intersectionality?

KS: All right. Can you explain the Bechdel Test, which is the finest thing ever happening?
AB: This is so funny. The Bechdel Test is the thing I'm really most well-known for.

KS: That's okay.
AB: And it's not even my thing. It's just gotten attached to my name. It's actually from a very, very old *Dykes to Watch Out For* episode from the eighties, about two women trying to figure out what movie to go to. And one of them says, "I can only see a movie if it has more than two women characters in it

who talk to each other about something besides a man." And I stole that from a friend of mine. She had just told me this story, and I didn't have an idea for my strip, so I just put in my comic strip.

And it was just a lesbian joke in the eighties, the kind of stuff we were all saying to each other. And it, you know, it just disappeared. But then, twenty years later, these young feminists resurrected it. I think it started with women in film school who were being told the exact opposite. "If you want to sell a movie to Hollywood, don't put more than two women in it," etc. So, it's just taken on this weird life of its own. There's, like, a website [where] you can go see if a movie passes it or not. You can discuss the finer points of why, or why not, it passes.

But it's really cool, because it's this real index of how the culture has changed. It was a very fringe, marginal thing in the eighties, and now it has become this more mainstream discussion, which is amazing.

KS: And continues to be true, which is astonishing, right?
AB: Not as true as it was, but yeah.

KS: More true?
AB: It's gotten a little better, but.

KS: Slightly, yeah. I don't know. I'm not too . . . I don't know.
AB: You're more jaded than I am.

KS: I am. Well, you know. It's interesting when you have kids. I have two kids.
AB: Oh.

KS: When you start to look at those movies, and . . . Like, you look at a movie like *Finding Nemo*. How many women are in the ocean? One, and she's crazy. It's Ellen. It's always Ellen, right? It's always a crazy lesbian.

Lee Marrs: It's Lee Marrs.
AB: Oh, hi, Lee.

LM: Hey Alison. Hi. I really enjoyed this different version of *Fun Home*.
AB: Well, I just have to say, Lee Marrs is a pioneering women's cartoonist. That's of the "Women's Comics" days, the old, real underground days. So, thank you. I'm glad you're here.

LM: Yes. We had to carve the rocks and all that good stuff. It was real trouble.

 You do a really good job, I think, of being a creative person in our society, because you work, you really work, and you have for years. And now that fame has come to you, you actually have retreated in order to remain creative, and that's very hard to do.

AB: It is hard to do. It's surprisingly hard to do. Like, I shouldn't be sitting here, talking in San Francisco. I should be home, working.

LM: Yeah, get to work.

KS: You know, the food is super good here, so.

AB: It is.

KS: Have just a little good time.

AB: Okay.

KS: Don't feel guilty. So, address what she said. What do you think about that? Because you are . . . Do you think of yourself as well known? I mean, you must.

AB: Well, yeah. It's very strange. I mean . . . Oh my God, I was waiting outside for an Uber today, and . . .

Audience 4: No Uber.

KS: No.

AB: Oh, oh. Really? Because of what they did about people going to airports yesterday?

KS: Right.

AB: Okay. Okay, I gotta get the other one. Sorry. Thank you. No, this is really cool. That's a kind of activism, right? I mean, it's making your values known.

Audience 5: Lyft donated a million dollars to the ACLU today.

KS: Who did? That's Lyft.

AB: Wow, okay. I'm totally deleting that app. Anyhow. I was waiting for this car, and this dyke pulled up in a car, and I thought, "Oh, that must be my driver." No, she was just some random lesbian who identifies me on the street and jumped out of her car, screaming. I mean, it's really weird. It's really weird.

KS: Do you like that?
AB: No, I really don't like it.

KS: Oh.
AB: I mean, it's novel at first, for a while. But it's quite draining and odd.

KS: Really? Huh. Did she give you a ride?
AB: No, but she almost got hit by a car that was coming to pick me up.

KS: So how did you react? What did you do?
AB: I was very friendly and talked to her, and took a selfie with her.

KS: Okay, all right.
AB: But it's weird. It's like, all the sudden, your life is interrupted by this bizarre force.

KS: Yeah.
AB: I'm not really complaining. Of course it's a really good thing, but it's just odd.

KS: Yeah. I always get approached by Indian geeks, so it's not quite as fun. I wish I was you.
AB: Do they want selfies?

KS: Yes, yes. "Oh, it's Kara Swisher, I cannot believe it." I wish I had your life. Okay. Two more quick questions.

Audience 6: Hi. So *Fun Home* the book has a very nonlinear structure, and I love that they kept that kind of jumping back and forth through time, and I was wondering, when you were writing it, did it come naturally to you? How did you come up with that kind of . . .
AB: Oh, no. It was really, really hard. It took . . . You know, I said it took me seven years to write that book mostly because I was just moving stuff around all the time and I didn't know how to write a book. I knew how to write a comic strip, but that was a very small, contained thing. It was just an organic process. I realized I didn't want to just tell the story of what happened to me. That's not really that interesting. But it was my ideas and feelings about what happened to me. And to do that, I had to break it apart chronologically and talk about it more thematically. So that meant the time got all screwed up.

KS: All right. Last question?

Audience 7: Hi. I was just wondering how you would have written things differently had your mother not been alive when you wrote 'em.
AB: Oh, that's an excellent question. You know, because I was very aware of her presence. Not just what she was gonna think of the book, but her editorial presence. 'Cause she was a writer, a thwarted writer, and a lot of my struggle was just being able to get her out of my head, as an oppressive editorial voice.

You know, the interesting thing, as I was writing the second book, the memoir about her, she actually was . . . very weirdly, she was diagnosed with cancer right when *Fun Home* was published. Like the week I was off on my book tour. And she lived for seven more years and saw the book about her. But I never knew if she was going to live to see it. Which was very strange, too. 'Cause there were different books that I could've written. But you're asking, what would have been different.

I like to think I would have been more honest. I tried to be as honest as I could, but I feel like I still was soft-pedaling things, at least in the book about my mother. I don't know. Sorry. I'm not sure if . . . It might not have been any different, you know? It's weird, too, because my parents' friends, many of them are still alive, and I often hear from them. They have their own versions of things.

KS: What do they say?
AB: Well, some of them are mad at me. Some of them don't think my dad was really gay. Many of them are actually kind of amazing, and they've come to see the play and they talk to me about it, and they come out of the play sobbing.

KS: Mm-hm.
AB: Yeah. It's very moving to see that.

KS: Well, everybody has their own reaction to everything. It's often not factual . . . even when it's not factual.
AB: Yeah.

KS: I'm sorry we can't take more questions, because Alison's gotta go. But I always ask this [of] everyone. If you could do anything next, what would you want to do? If you weren't doing this, if you could pick something—or do you really like the life you have, and the way you've built it? If there was one thing that you haven't done, that you've wanted to do?

AB: I do really love my life. Even if you gave me a billion dollars to do something else, I don't think I would. But, you're saying, I have to pick something.

KS: Yeah.

AB: I think it would be . . . I just had this image of . . . Can I just, like, take trapeze classes?

KS: You know, Alison, you can do that now.

AB: I did. I took one, and it was so fun.

KS: Why not two?

AB: Well, I mean, I don't have that much time.

KS: Well, you are gonna die someday, so what's the difference?

AB: I would just want to do fun things like that. Fun, physical things. Just, like, playing. If I could do that.

KS: You should.

AB: All right.

KS: All right. All right. Everybody, Alison Bechdel.

AB: Thank you, Kara.

INDEX

CPSIA information can be obtained
at www.ICGtesting.com
Printed in the USA
BVHW03s1525140918
527490BV00002B/10/P